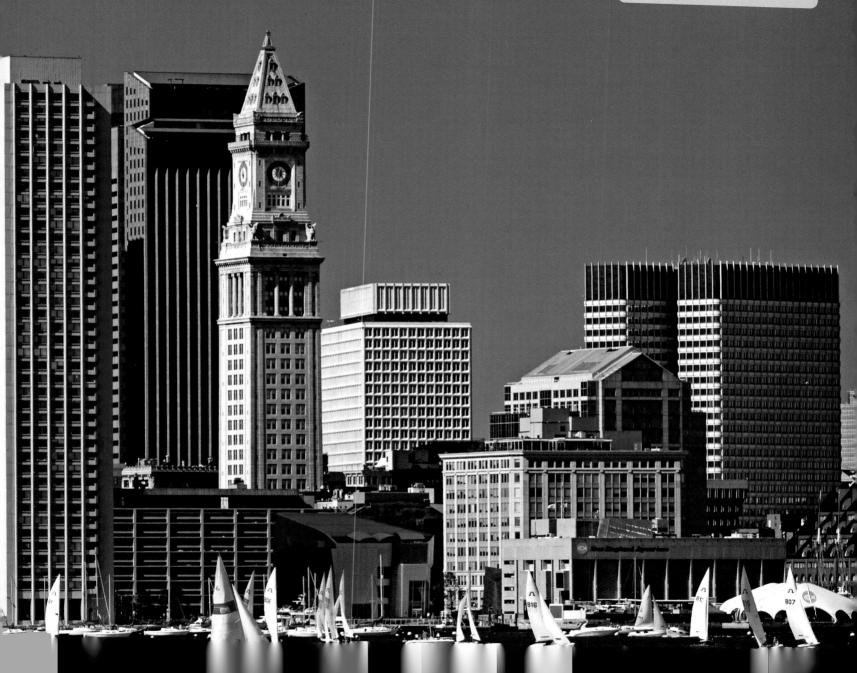

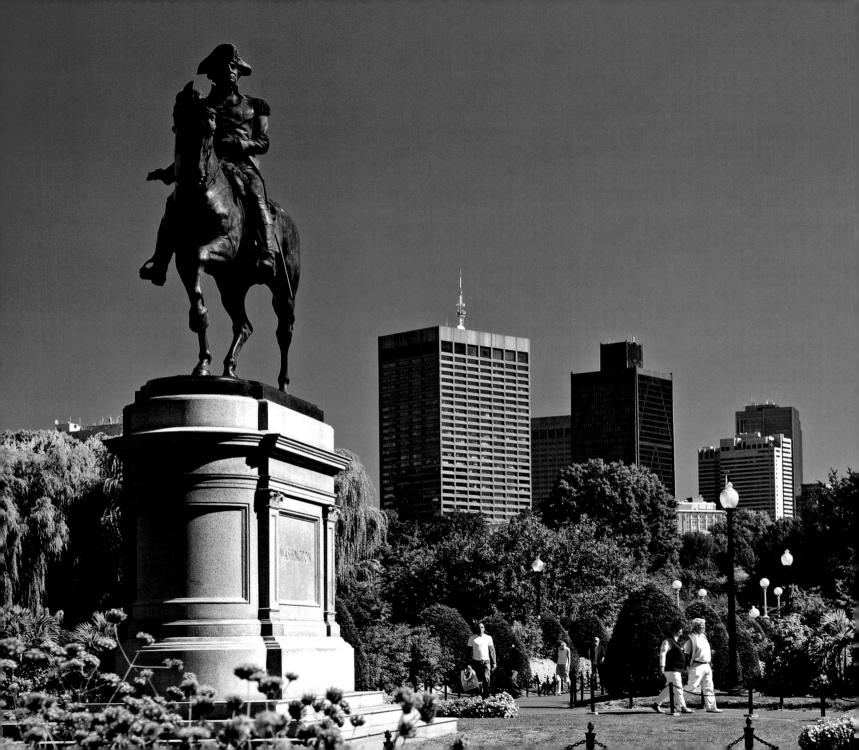

BOSTON IMPRESSIONS | PHOTOGRAPHY BY RICHARD NOWITZ

Right: Fan Pier provides one of the finest views of the Boston skyline rising above Boston Harbor.

Below, **left**: Ye Olde Union Oyster House has been serving libations and Yankee-style seafood since 1826. In their time, this quaint colonial establishment was a favorite hangout of Daniel Webster and John F. Kennedy.

Below, right: The Italian North End has a strong tradition of honoring the old country. This is the place to find many fine ristorantes, as well as pasticcerias that offer delectable biscotti, taralli, cannoli, and other extraordinarily good Italian pastries.

Title page: Holding its own among high rises, Trinity Church, built on Copley Square and dedicated in 1877, stands as a firm reminder of early Boston architecture.

Cover: The Thomas Ball statue of George Washington rides forever in the public garden.

Back cover: Raindrops on the Prudential Tower's window create an impressionistic view of Boston.

ISBN 10: 1-56037-437-3 ISBN 13: 978-1-56037-437-4

© 2008 by Farcountry Press Photography © 2008 by Richard Nowitz

All rights reserved. This book may not be reproduced in whole or in part by any means (with the exception of short quotes for the purpose of review) without the permission of the publisher.

For more information about our books, write Farcountry Press, P.O. Box 5630, Helena, MT 59604; call (800) 821-3874; or visit www.farcountrypress.com.

Created, produced, and designed in the United States. Printed in China.

13 12 11 10 09 08 1 2 3 4 5 6

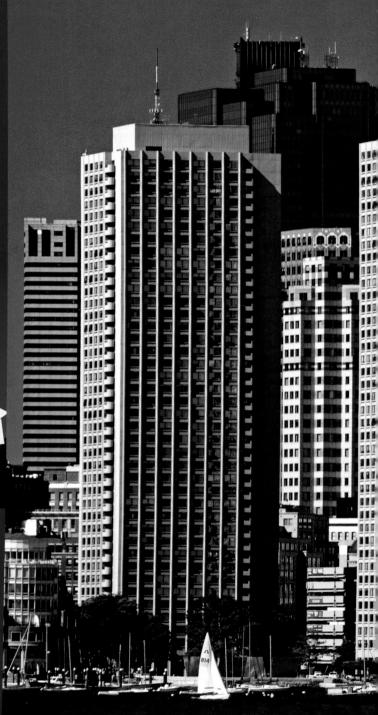

Facing page: Established in 1837, the twenty-four-acre Public Garden was the first public botanical garden in the nation. The Thomas Ball statue of George Washington depicts another first—the former president seated on a horse.

Below: (left) Adjacent to the Public Garden, Boston Common carries a long history of hosting public events, from a witch-burning to the pope saying mass here. (middle) The Angel of the Waters, by Daniel Chester French, was placed on Boston Common in 1924. (right) The foot-propelled swan boats have carried people across the lagoon in the Public Garden since the 1870s.

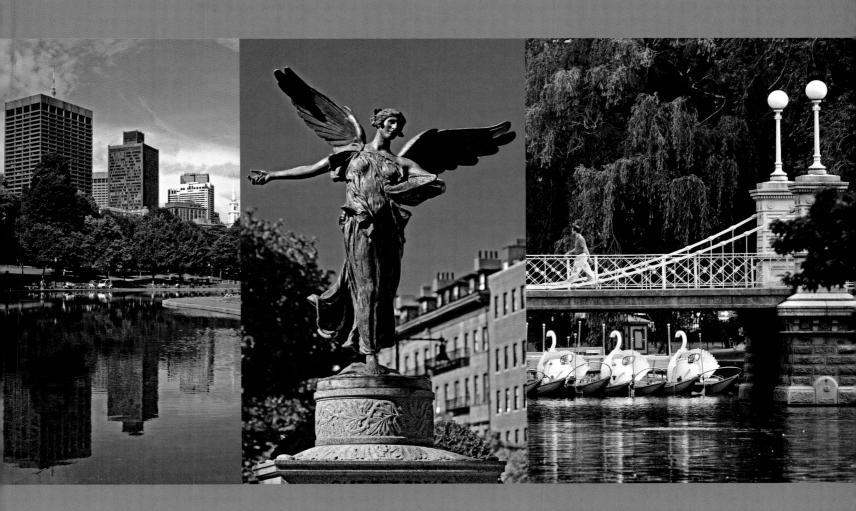

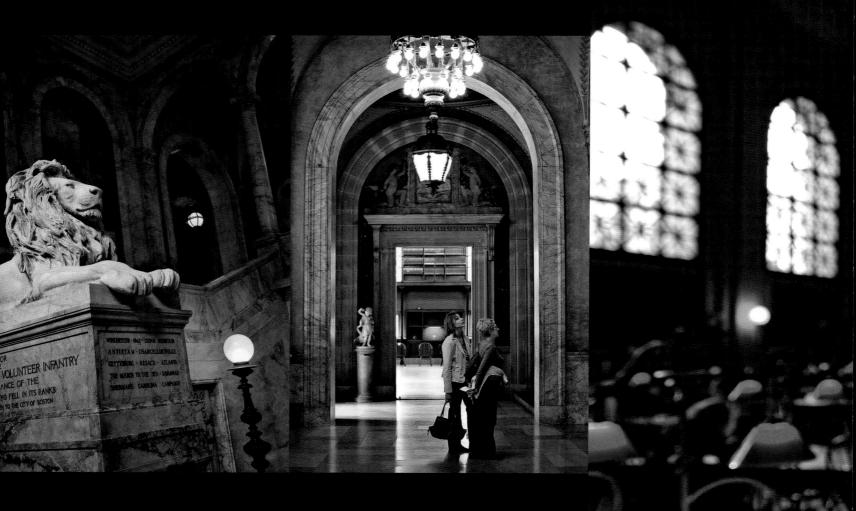

These pages: Now designated a National Historic Landmark, the Boston Public Library, completed in 1895, houses the nation's first large, free, municipal library. This carved marble lion guards the monument honoring the volunteer Massachusetts Civil War infantrymen fallen in 1862. The second-floor corridor gallery features murals by French artist Pierre Puvis de Chavannes. The impressive barrel-arch ceiling in Bates Hall shelters busts of prominent Bostonians, including Benjamin Franklin.

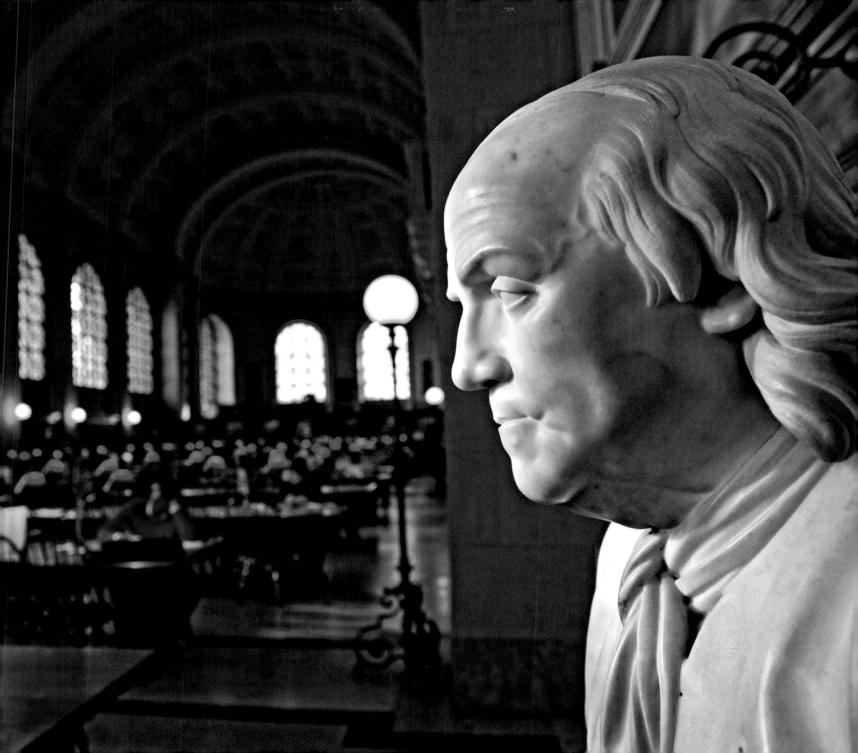

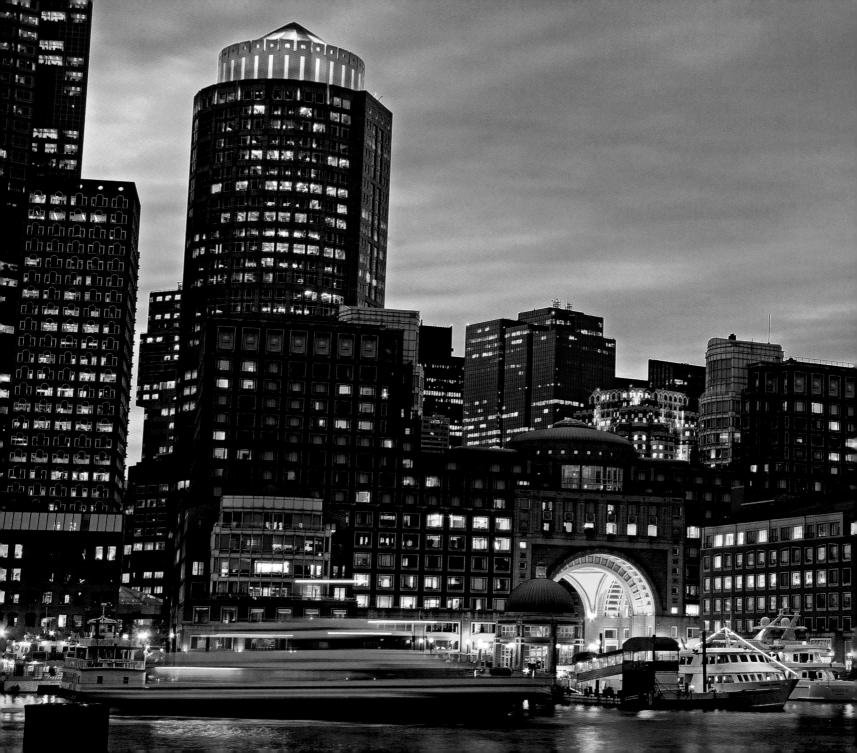

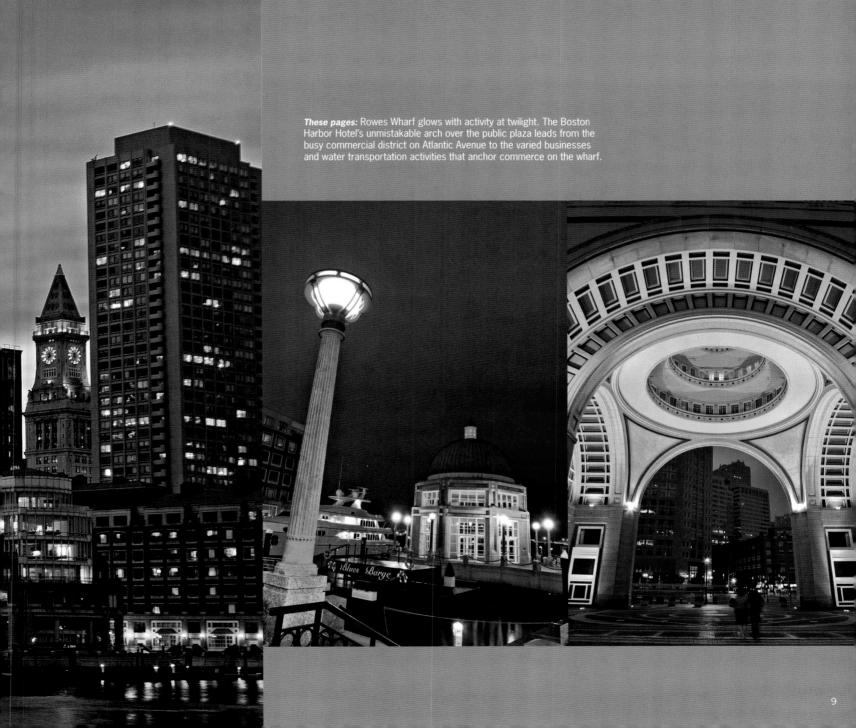

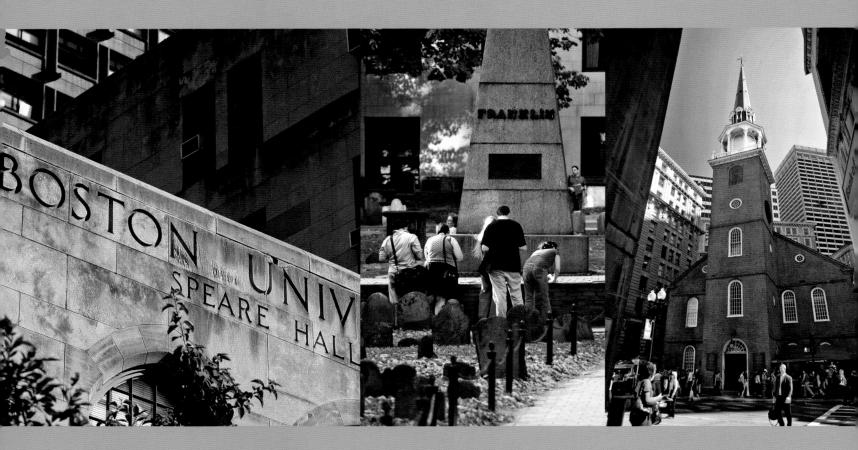

Above: (left) Speare Hall is one of Boston University's 324 buildings. (middle) Bostonians first used the grounds of their old granary as a burying ground in 1660. (right) Built in 1729 by Puritans to be a house of worship, in 1773 more than 5,000 angry colonists met here in Old South Meeting House and their protest about the tax on tea ended with dumping 342 chests of tea in Boston Harbor, now famously called the Boston Tea Party.

Facing page: A National Historic Landmark that faces Copley Square, Old South Church exemplifies Northern Italian Gothic architecture. Its bell tower and copper cupola are easily recognizable from many vantages within the city. Today's long-distance runners recognize it as the Boylston Street finish of the Boston Marathon.

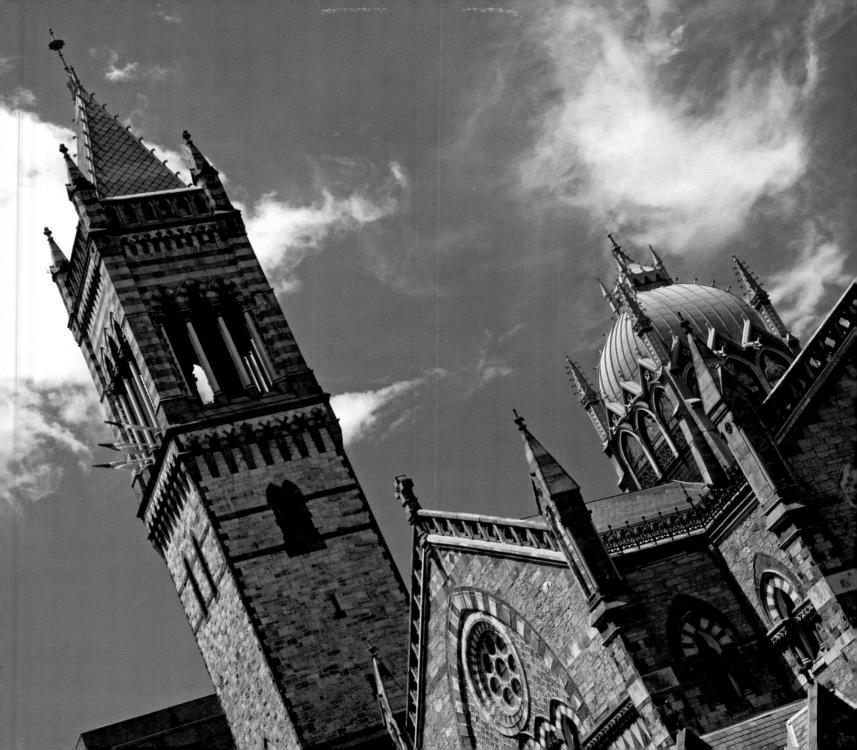

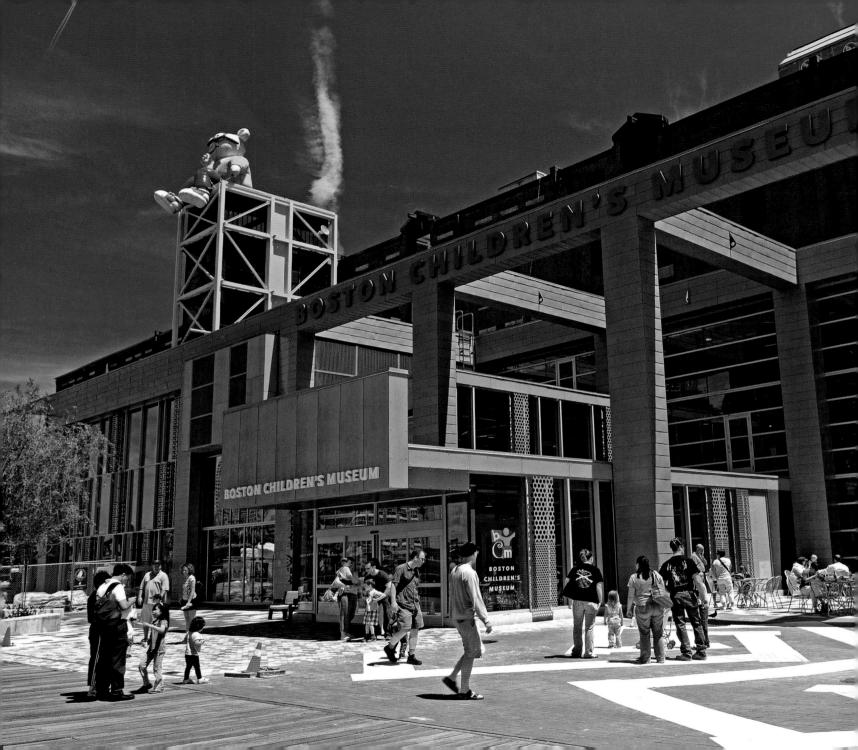

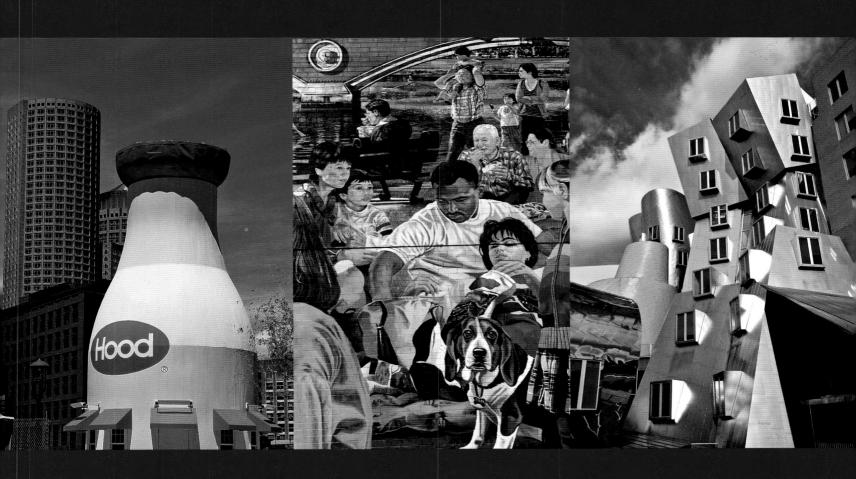

Above: (left) The forty-foot-tall Hood Bottle marks the entrance to the Children's Museum. (middle) Local artist David Fichter painted the mural Sunday Afternoon on the Charles River on the outside wall of Trader Joe's, in Cambridge. (right) Unexpected angles and shapes define the Ray and Maria Stata Center for Computer, Information and Intelligence Sciences at Massachusetts Institute of Technology (MIT). The facility won a Grand Award from the American Council of Engineering Companies in 2005.

Facing page: The Boston Children's Museum targets children under eleven years old with interactive exhibits that include the Construction Zone, Global Gallery, Boston Black, Science Playground, and Boats Afloat.

Right: Sunshine brings out the sheen of 23-carat gold overlaid on the copper-roofed Massachusetts State House. Originally, the 1798 Capitol building's dome was covered in a far more drab fashion, using wood shingles.

Below: (left) Architect Charles Bulfinch designed the Massachusetts State House (also called the new State House). (right) Inside, Memorial Hall's stained glass skylight features the seals of the original thirteen states.

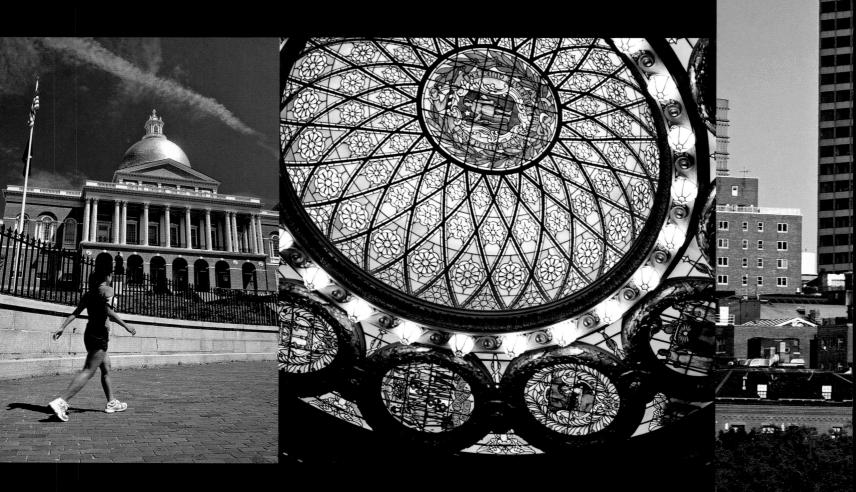

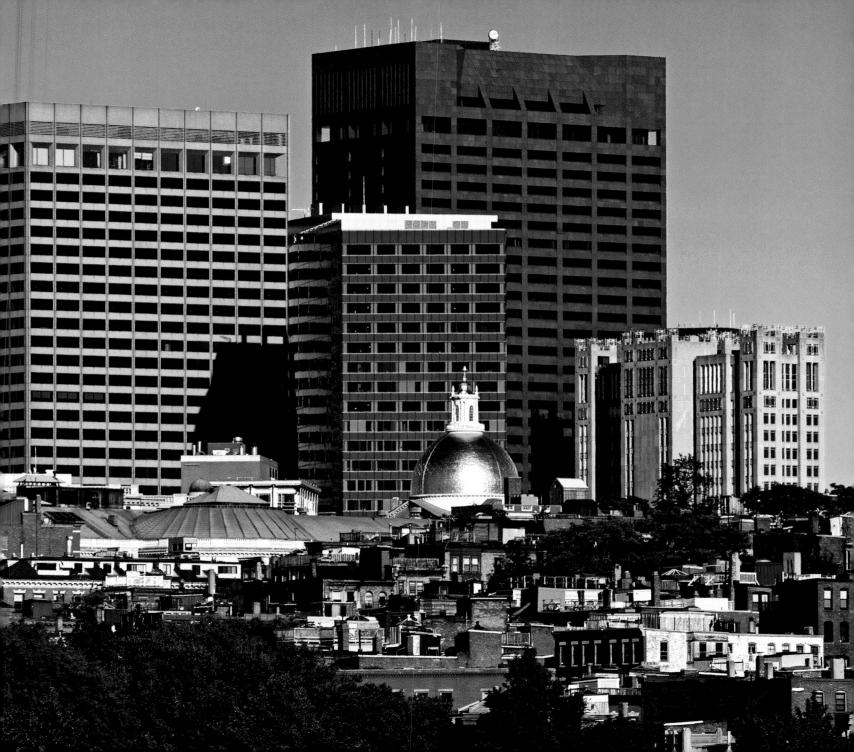

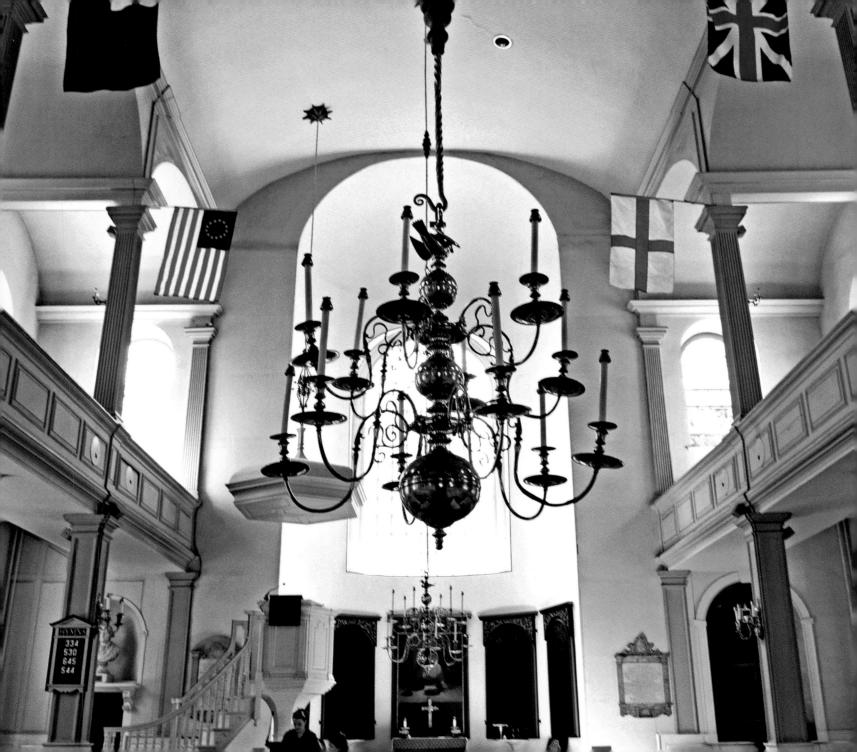

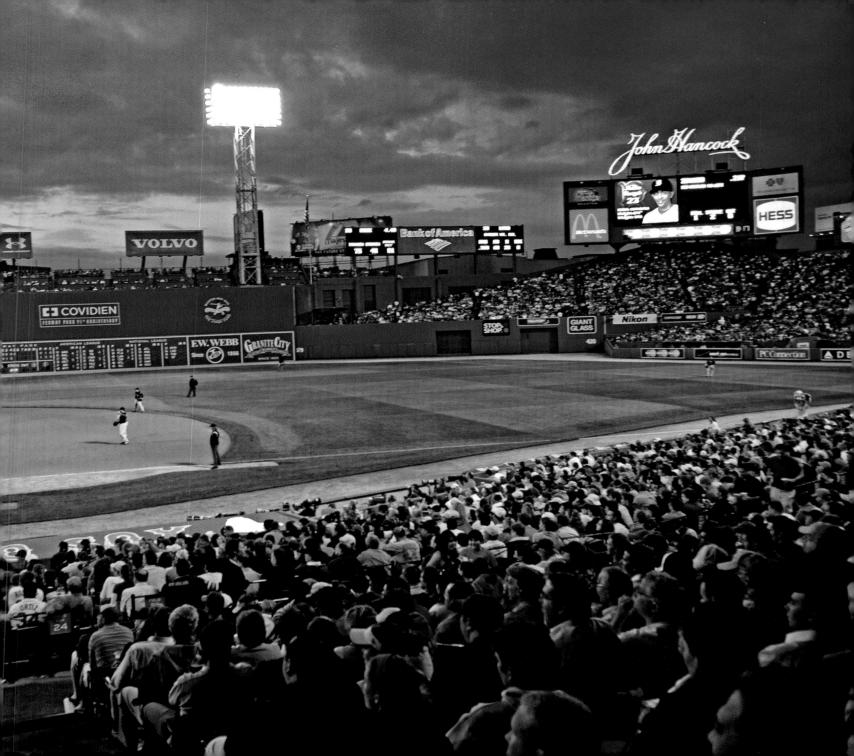

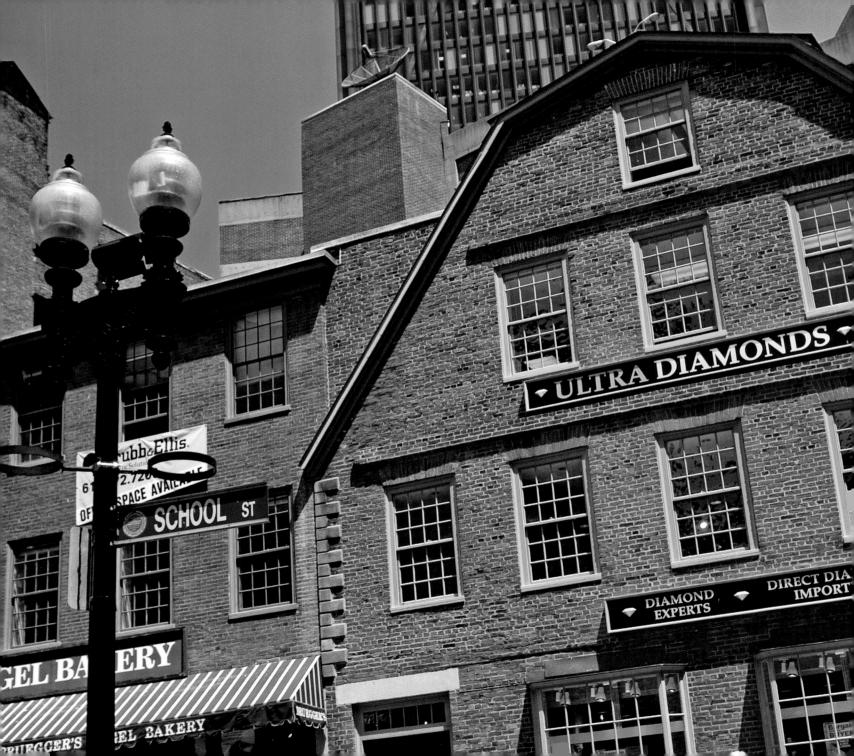

Facing page: Boston has long been celebrated as a place of learning. Now housing a diamond dealer, in its time the Old Corner Bookstore served as a gathering place for celebrated authors, including Henry Wadsworth Longfellow, Ralph Waldo Emerson, Nathaniel Hawthorne, Henry David Thoreau, Harriet Beecher Stowe, Charles Dickens, Louisa May Alcott, and Oliver Wendell Holmes, Sr.

Below: (left) The red brick Freedom Trail traces a path to sixteen nationally significant historical sites. Informative guides in period costumes lead tours, or you can purchase an audio guide and do it yourself to learn about the Boston Latin School, the city's first free public school, established and run for boys until 1972, when girls were admitted. (middle) Brass markers ensure you stay the course on the Freedom Trail. (right) Built circa 1680, the wood-sided Paul Revere House is the oldest in downtown Boston. It is now operated as a museum.

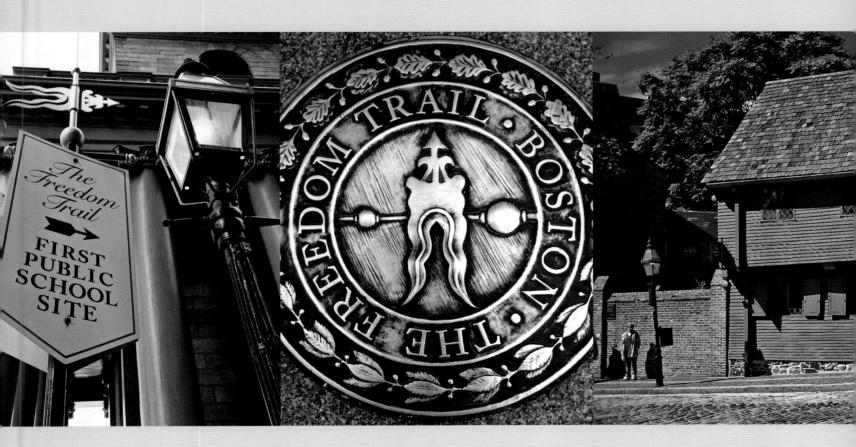

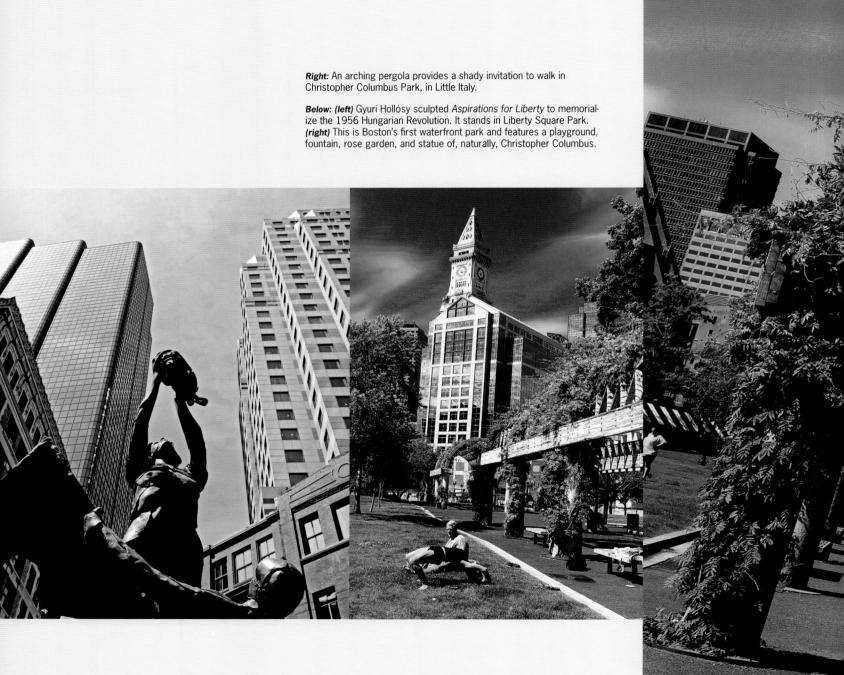

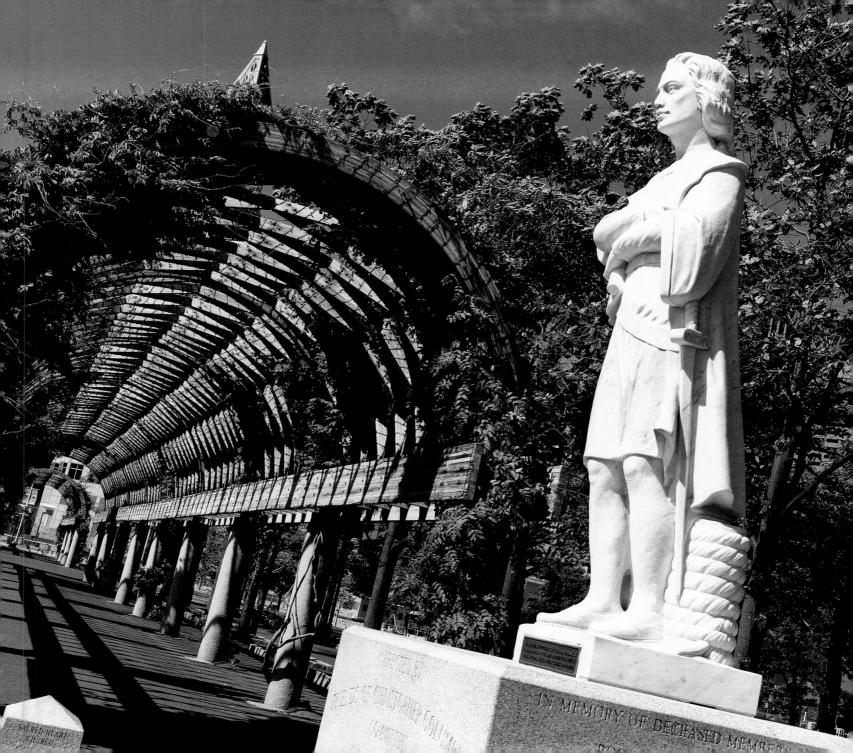

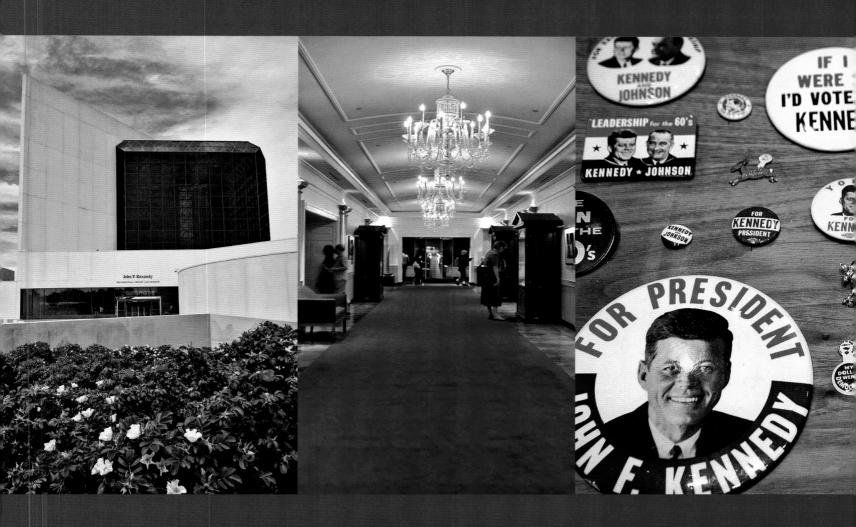

These pages: The John F. Kennedy Presidential Library and Museum offers a place for political research and portrays the life, campaigns, leadership, and legacy of our nation's thirty-fifth president. The facility is sited on a ten-acre park that overlooks the ocean and the city.

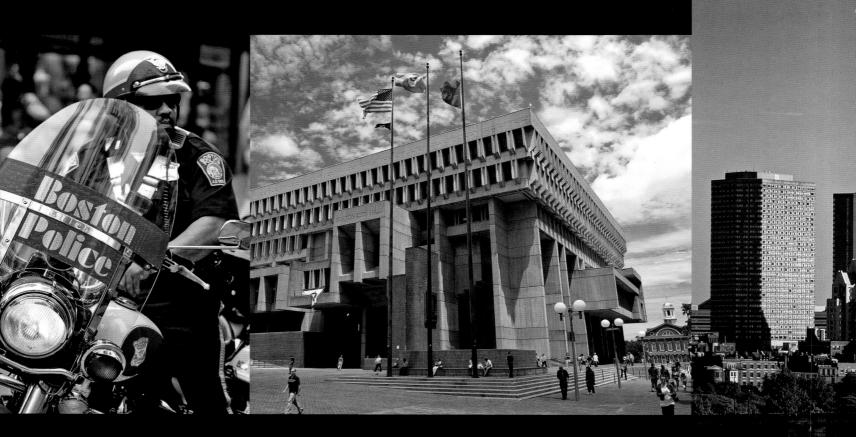

Above: (left) A police officer keeps an eye on traffic at City Crossing. (right) Boston's contemporary City Hall, built 1963–68, is built in a functional style called brutalist modern.

Right: The Longfellow Bridge spans the Charles River to join Boston and Cambridge. Completed in 1908, it replaced the West Boston Bridge that had been constructed in 1793. In 1927 the city renamed the bridge to honor Henry Wadsworth Longfellow. This 2,135-foot-long span, rehabilitated in 1959, contains sidewalks as well as a roadway.

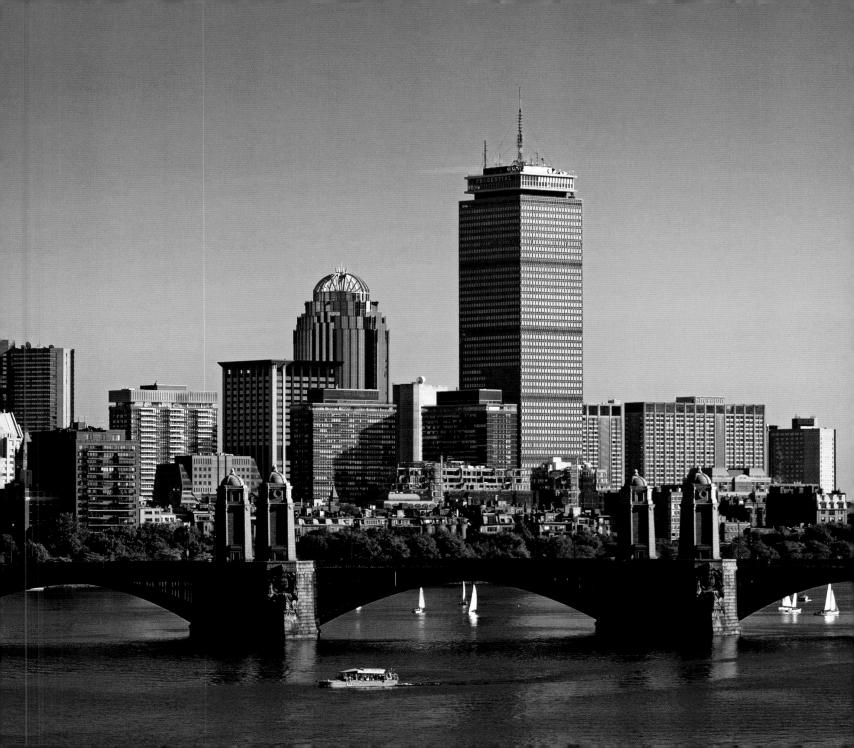

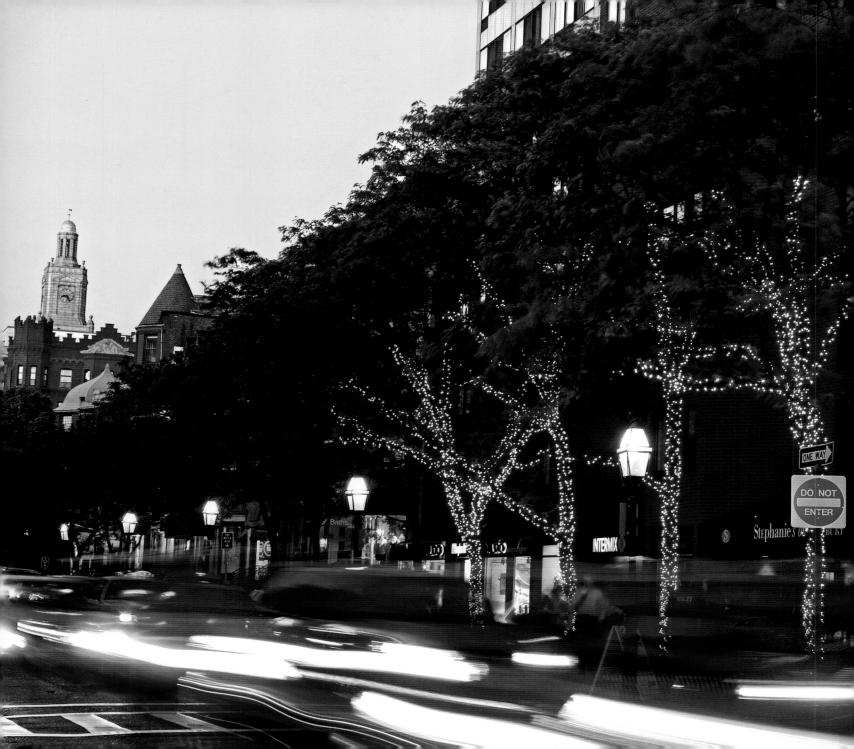

These pages: Now the epicenter of fashion and dining, Newbury Street boasts exclusive, eclectic, high-end establishments. This street and the rest of the "Back Bay" was inhabited by fish until the mid 1800s; the neighborhood was created by dumping dirt and fill from nearby communities and hilltops into the water. By the 1880s the new buildings with modern plumbing and electricity had become as desirable an address as Beacon Hill.

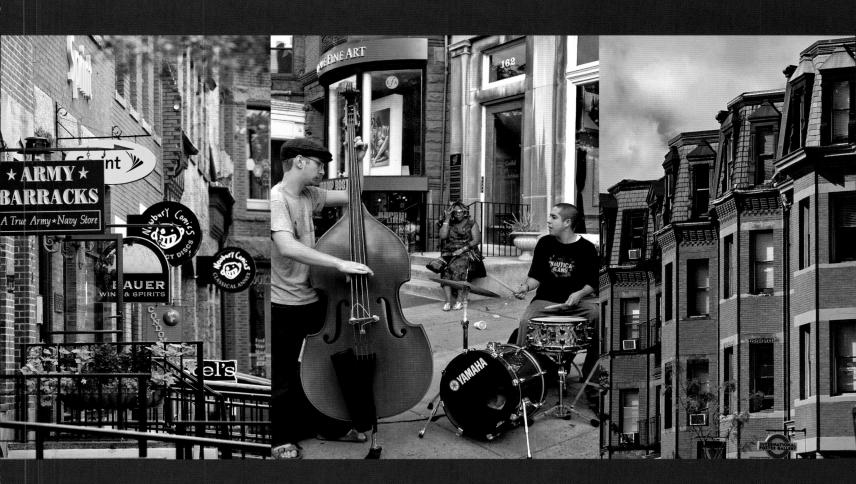

tions. Its second prominent, influential minister was Jonathan Mayhew, whose strong oratory influenced patriots including John and Samuel Adams, and John Hancock. The congregation later sheltered escaped slaves as part of the Underground Railway. The structure also served as a public library for sixty-six years while the city was undergoing dramatic demographic changes in the early 1900s. It's now known as Old West Church.

Below: (left) After the American Revolution, Harrison Gray Otis served Boston as a congressional representative and as its mayor. His home, now fully restored to its original Federal style and a National Historic Landmark, houses the Historic New England organization's library and archives. (right) This ornate gated entry opened to the 1899 Burrage House, which has been converted from a single-family mansion into condominiums.

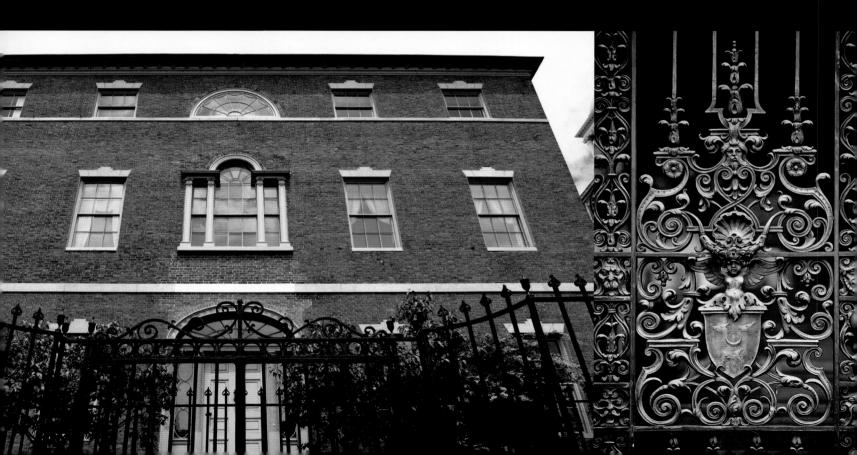

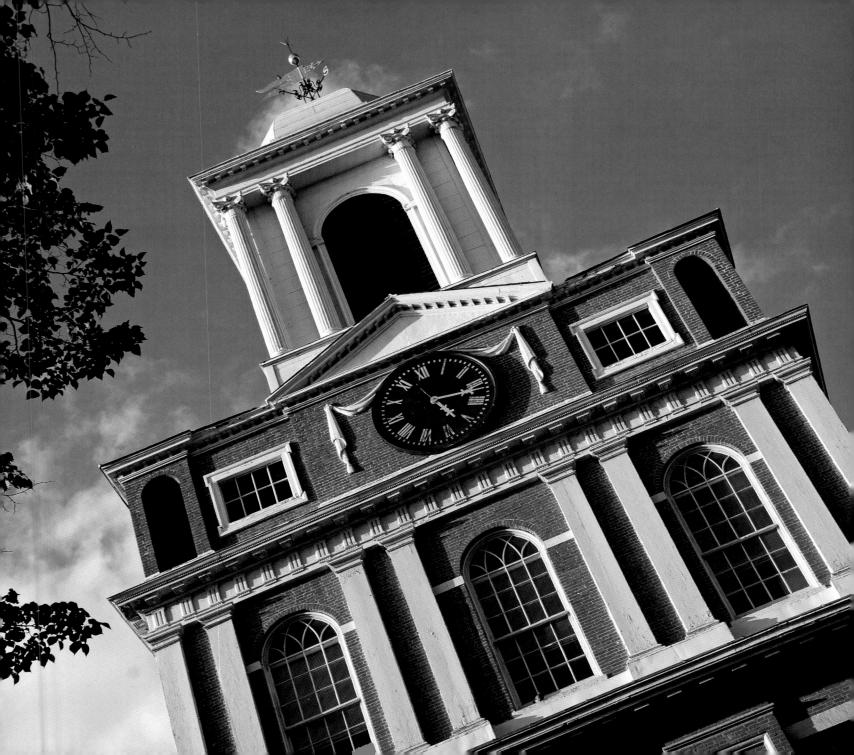

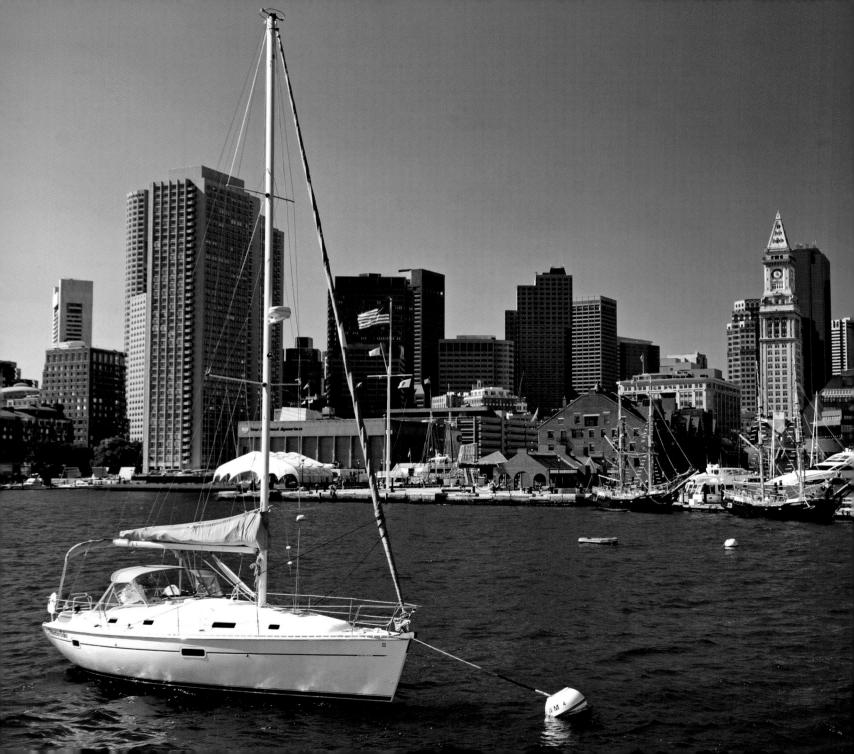

Left: Sailboats and yachts are moored at Fan Pier, in Boston Harbor. Boston has been a water-oriented city since its inception. The Port of Boston's commerce includes energy facilities, fish processing, automobile imports, cruise ship terminals, boat building, ship repair, and tugboat operations.

Below: (left) Boston Duck Tours' conDUCKtors provide an informative, entertaining narrative while cruising Boston Harbor and the Charles River. These renovated vessels are authentic WWII amphibious landing vehicles. Other seagoing travelers also have discovered the attractions of Boston. In 2006, more than a quarter million passengers arrived here on cruise ships. (right) The Boston Light, first lit in 1783 on Little Brewster Island, is the oldest light station in the nation. The original light was in a stone tower built in 1716 that was blown up by the British in 1776. The light in today's eighty-nine-foot tower was automated in 1998. Little Brewster is one of the thirty-four islands within the Boston Harbor Islands National Park, established in 1996.

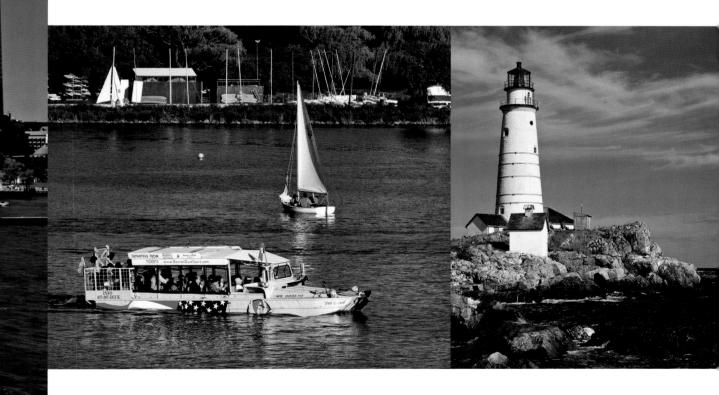

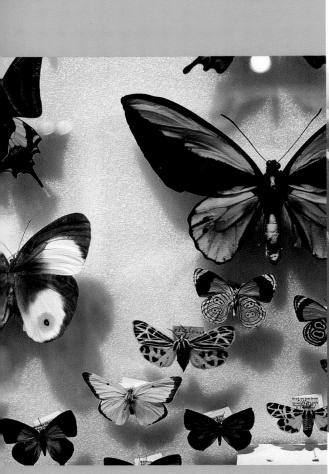

Above: Butterflies are displayed at the Harvard Museum of Natural History, at Harvard University in Cambridge. As well, visitors can see the skeleton of one of the first *Triceratops* ever discovered, and wonder at a 1,642-pound amethyst geode.

Right: Harvard University's Memorial Hall is considered one of the finest examples of Ruskinian Gothic architecture outside of England. It took eight years to build the elaborate structure. Memorial Hall was dedicated in 1878 to honor the Harvard graduates who had fought for the Union cause.

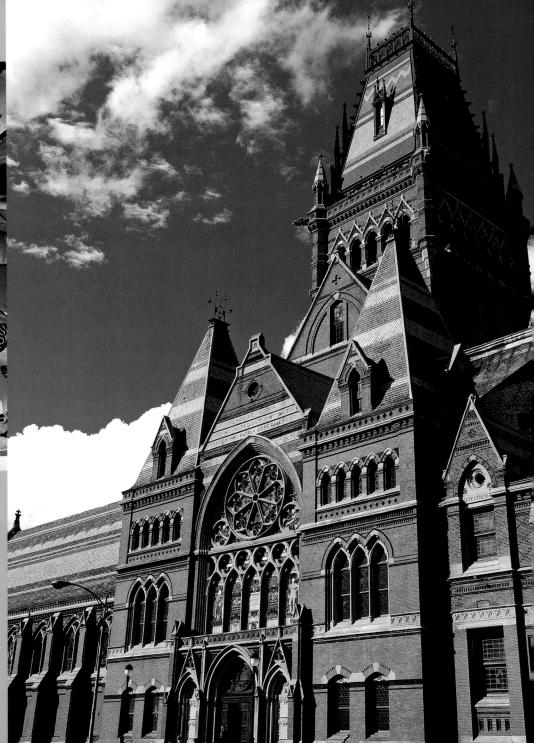

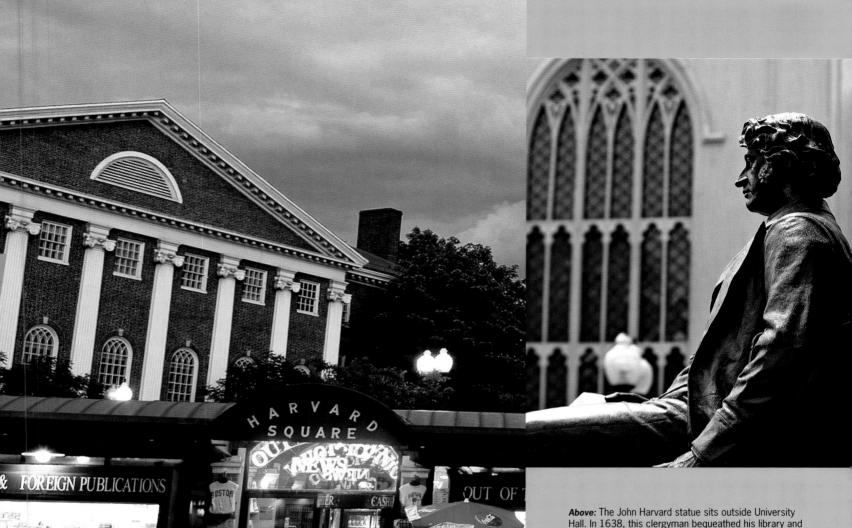

Above: The John Harvard statue sits outside University Hall. In 1638, this clergyman bequeathed his library and half his estate to a fledgling college founded in 1636, making Harvard the oldest college in the nation. It began with nine students and one instructor; now more than 2,000 faculty educate 18,000 students annually.

Left: Harvard Square is renowned for its shops, restaurants, and cultural events.

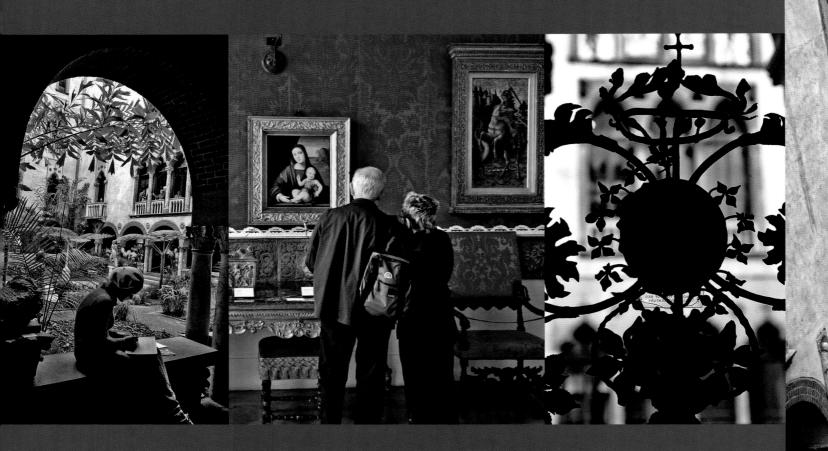

These pages: Isabella Stewart Gardner opened this museum in 1903 to share her collection of art that spans thirty centuries around the world, the elaborate and serene garden courtyard, and fine chamber music. The collection includes more than 2,500 pieces, includes Botticelli's *Tragedy of Lucretia*, Titian's *Europa*, Vermeer's *The Concert*, and Rembrandt's *Self-Portrait*. Her tradition of chamber concerts has continued since the museum's opening.

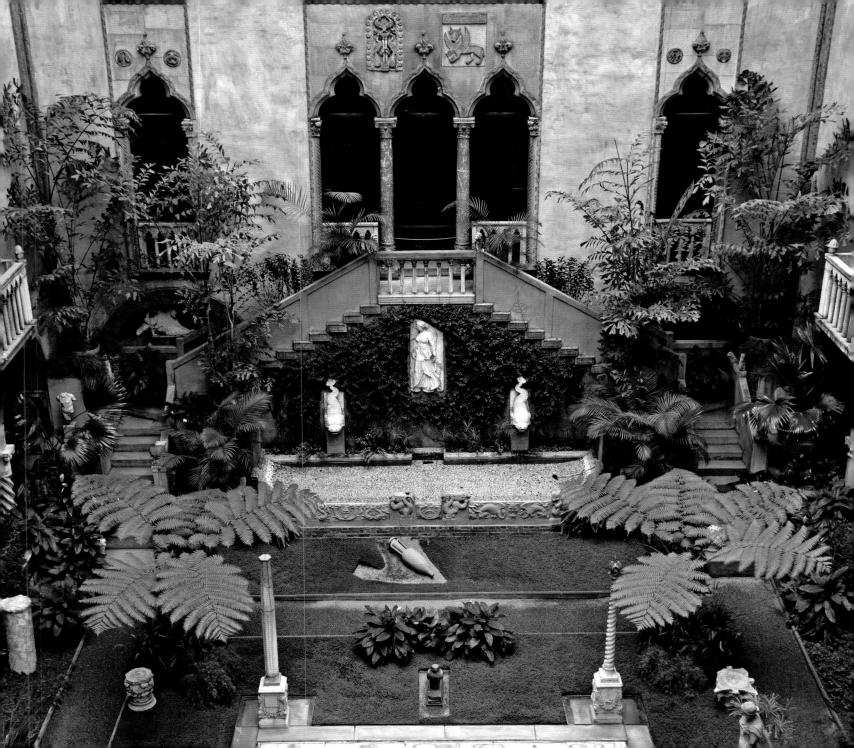

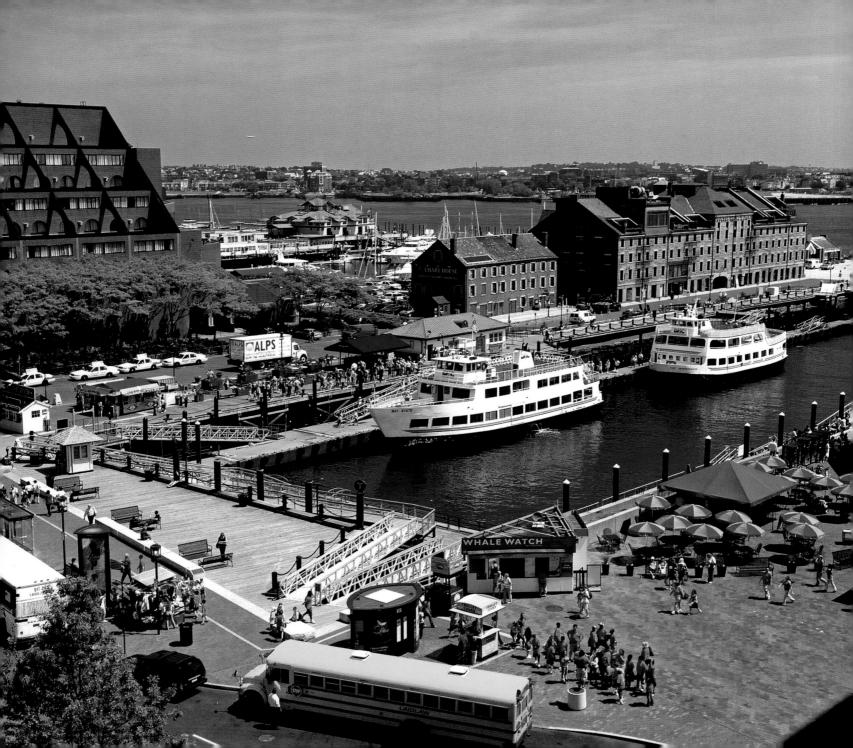

Facing page: Long Wharf and Central Wharf were critical components of the city's historical shipping industry. The industry thrives today. Annually, Boston's Working Port generates \$2.4 billion in economic impact and provides 34,000 jobs.

Below: (**Ieft**) Eat them or view them: Central Wharf hosts seafood vendors as well as the New England Aquarium. (**middle**) Skulling is a common sight on the Charles River. (**right**) This seafood platter awaits a hungry diner.

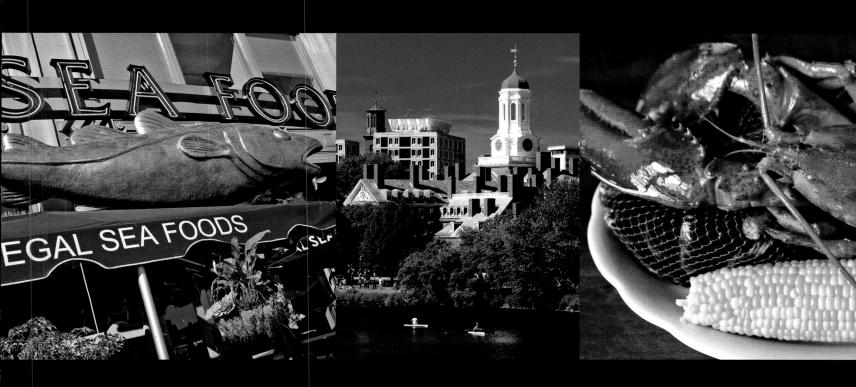

Right: The immense Maclaurin Buildings define three sides of the Great Court.

Below: Images on the Massachusetts Institute of Technology (MIT) campus. (Ieft) Simmons Hall, a dormitory dedicated in 2002, has more than 5,500 windows. (middle) Henry Moore's 1976 bronze sculpture in Killian Court (also called the "Great Court") is titled Three-Piece Reclining Figure, Draped. (right) Tony Smith's 1961 steel sculpture For Marjorie measures eighteen feet high.

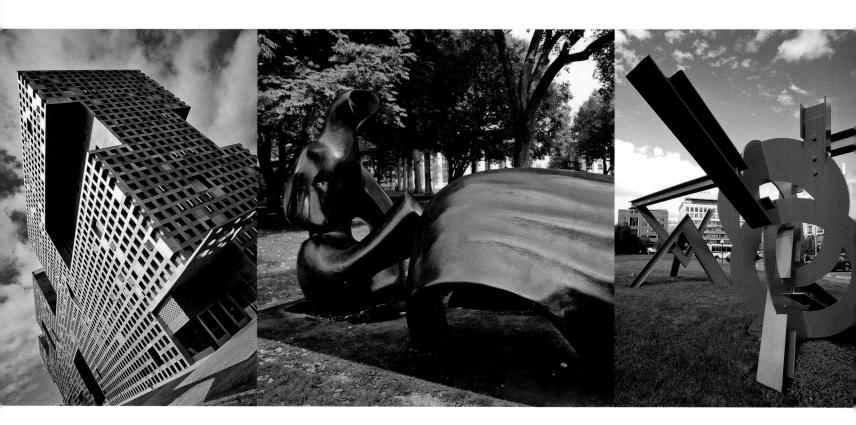

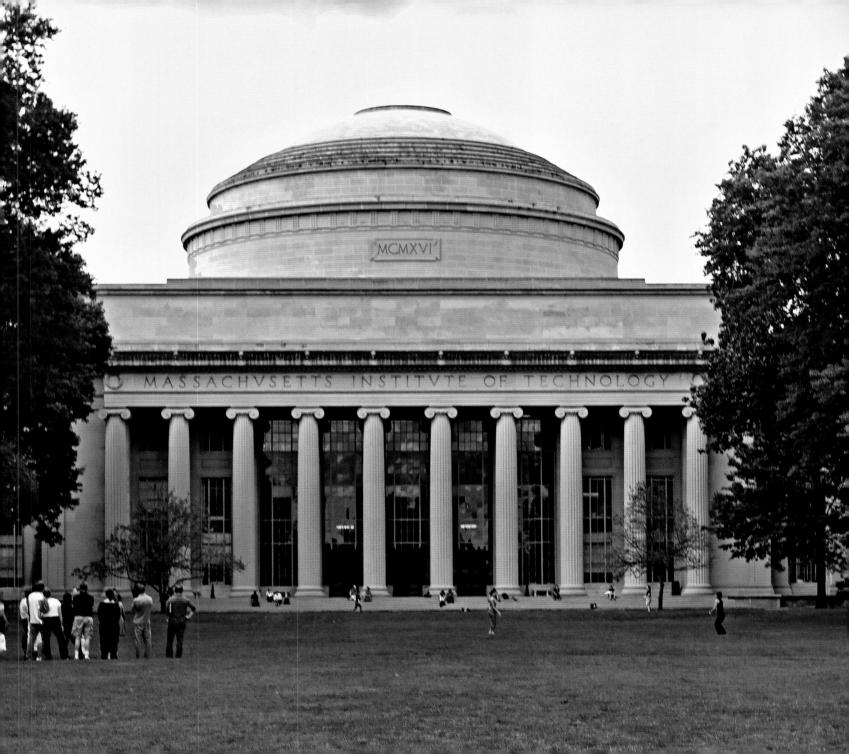

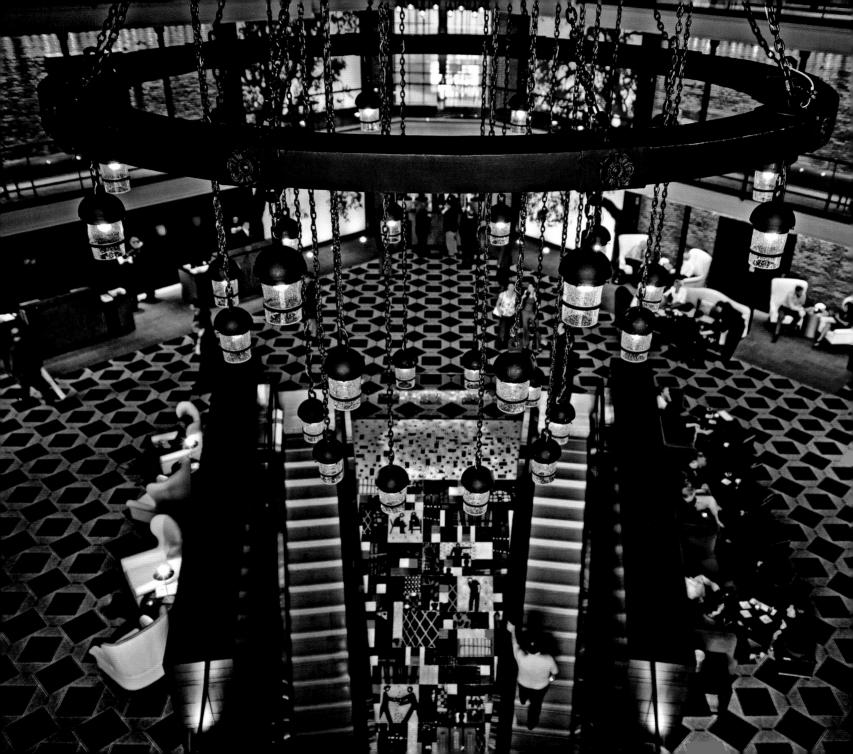

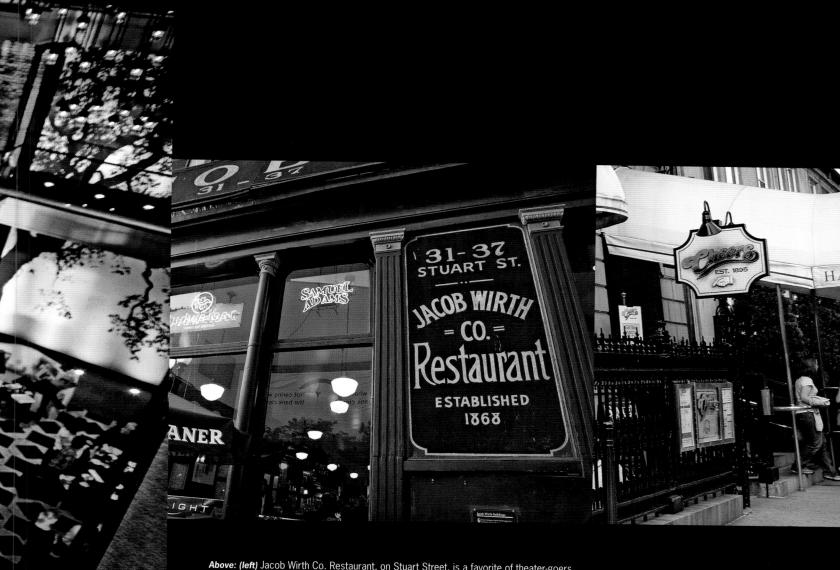

Above: (left) Jacob Wirth Co. Restaurant, on Stuart Street, is a favorite of theater-goers. (right) Cheers, a bar made famous by the television show of the same name, fronts on Beacon Street, in the Back Bay.

Left: An investment of \$150 million transformed this 1851 jail on Beacon Hill into the luxury accommodations of today's Liberty Hotel. For fun, architects preserved vestiges of jail cells in the lobby bar.

Right: Annually, more than 200,000 people ride the elevator in the Prudential Center's tower to a viewing platform on the fiftieth floor to admire the 360-degree view of Boston, as shown here. Boston is one of America's oldest communities, chartered as a town in 1630 and as a city in 1822.

Below: (left) The T Line, at a Northeastern University stop. Boston's mass transportation began in 1631, with a family-operated ferry service between Chelsea and Boston. (right) Fan Pier provides a view of anchored sailboats under the Charlestown Bridge, with the financial district in the background.

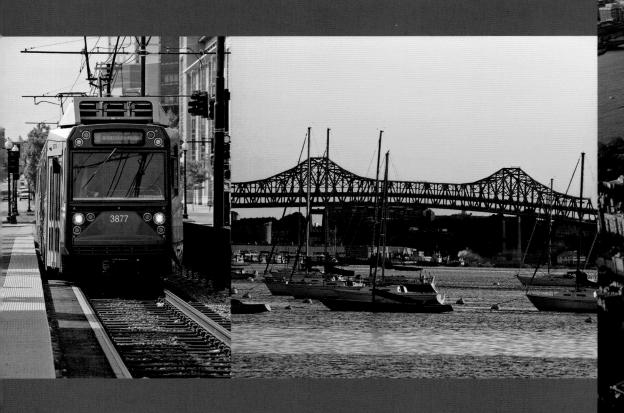

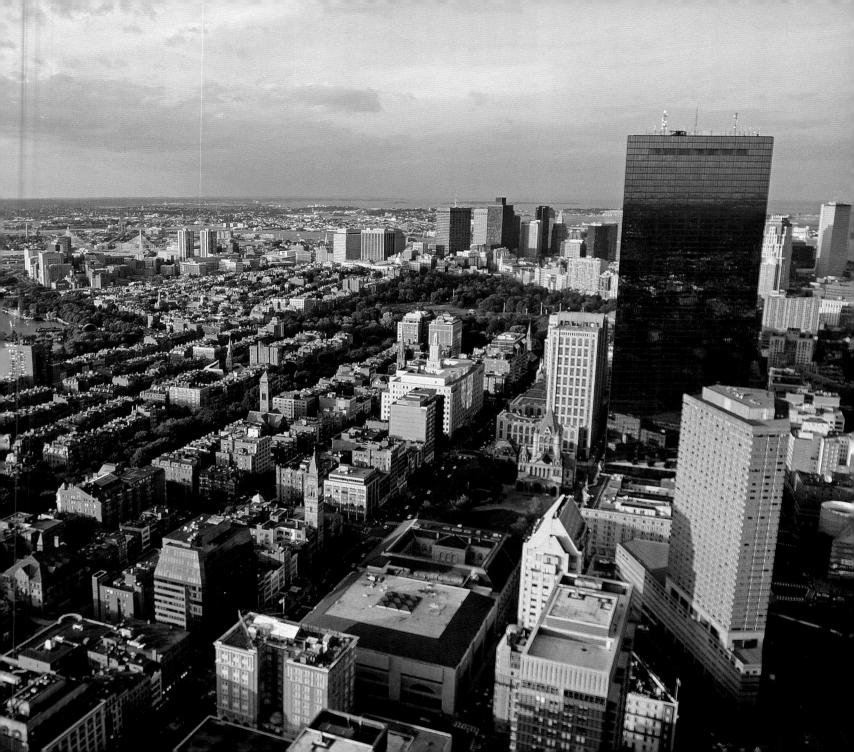

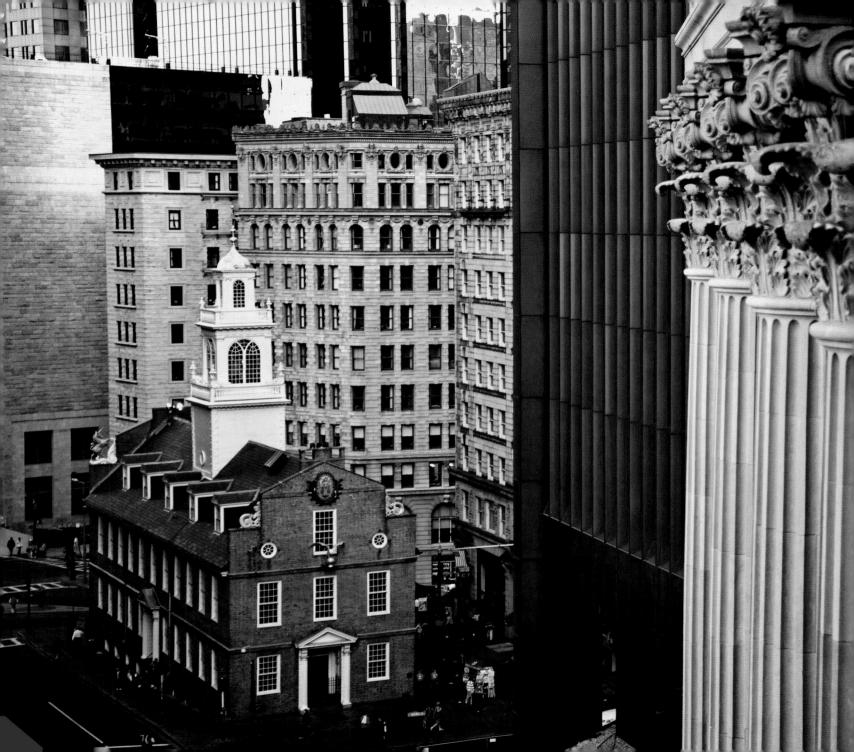

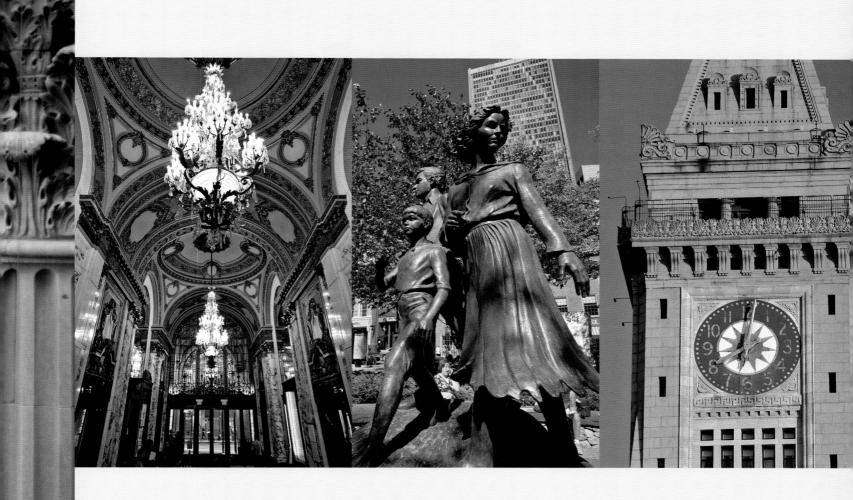

Above: (*left*) Elaborate rococo decorations define the Cutler Majestic Theatre, built in 1903 in the heart of the theater district, at Emerson College. (*middle*) The Boston Irish Famine Memorial commemorates a terrible time in Ireland's history; this statue grouping is sited along the Freedom Trail just a few blocks from where Irish refugees crowded into tenement housing. (*right*) The twenty-six-floor tower was added in the 1910s atop the 1847 Customs House.

Left: Now called the Old State House, this National Historic Landmark built in 1713 served as a merchants' exchange as well as the seat of colonial and state governments. Today the Bostonian Society chronicles Boston's history in exhibits displayed within the brick building.

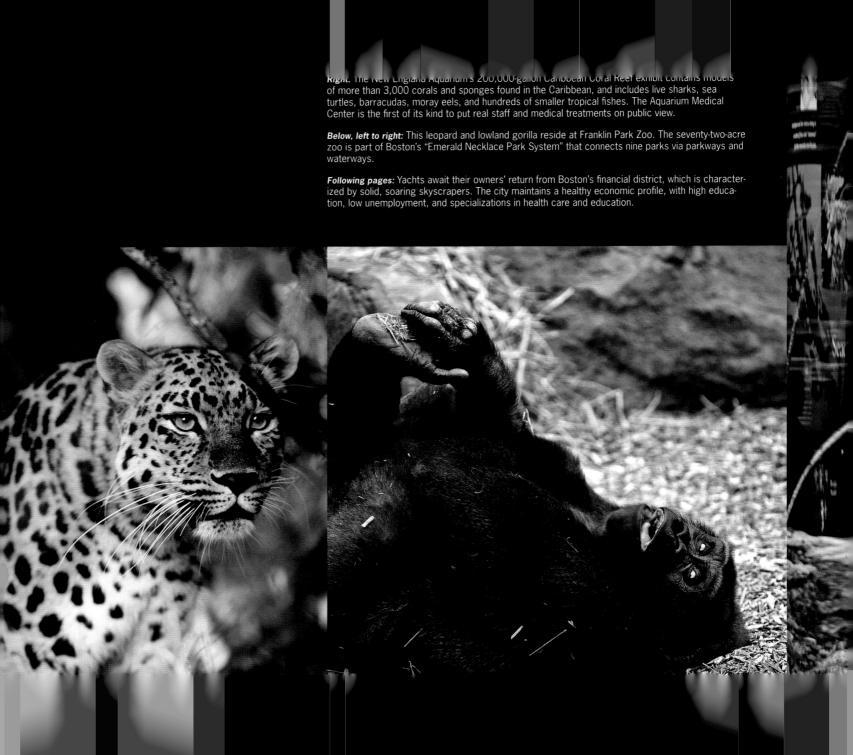

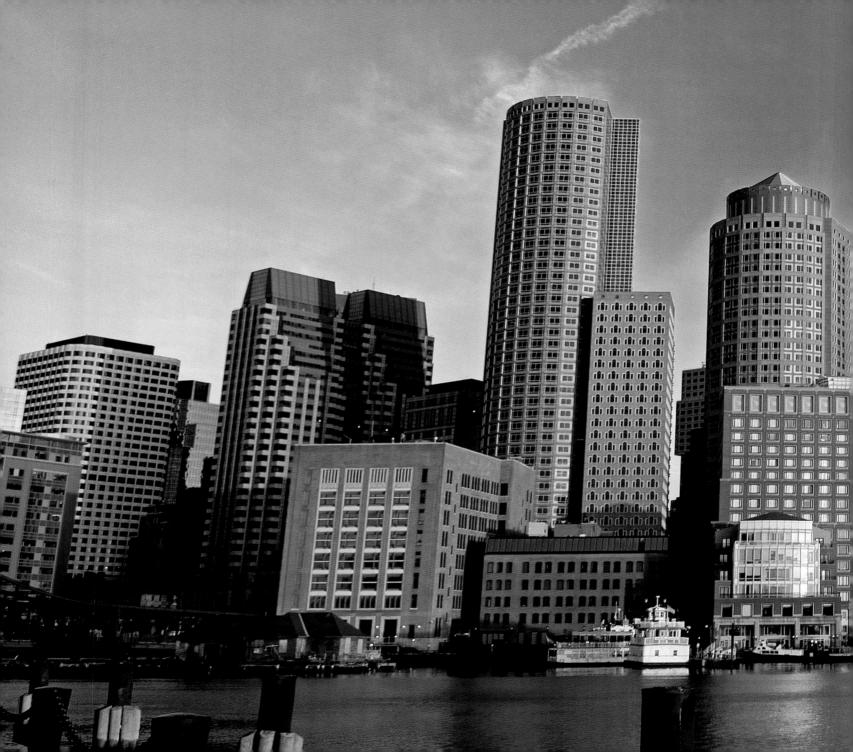

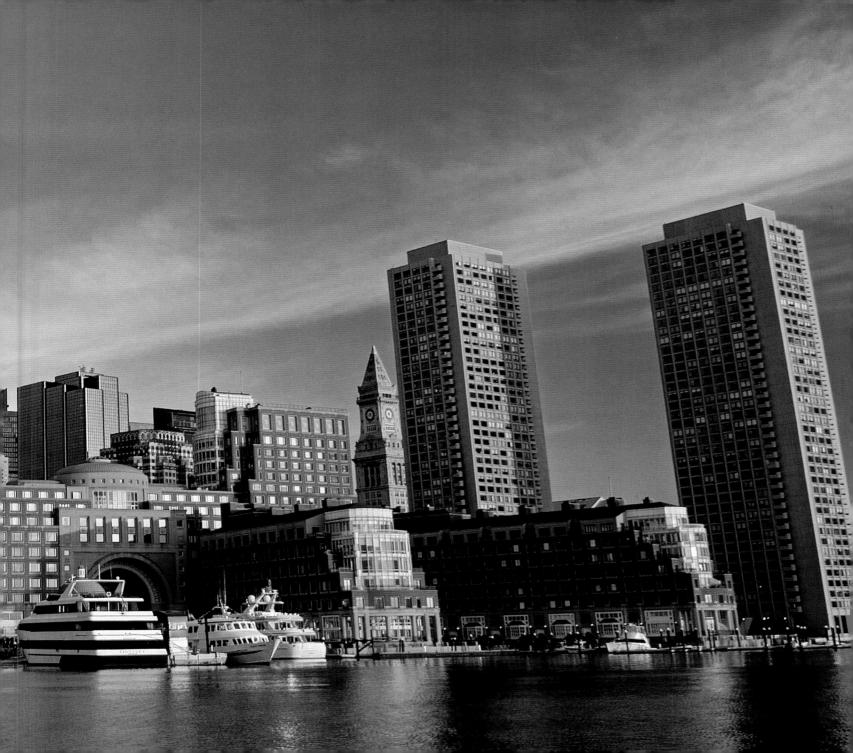

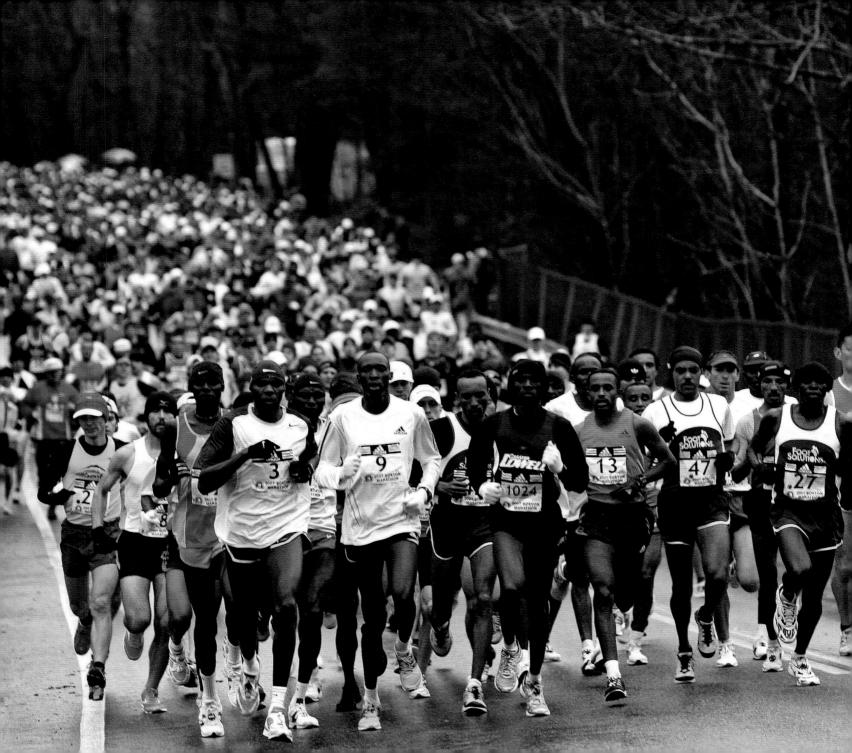

Facing page: The world's oldest annual marathon (established in 1897), the Boston Athletic Association's Boston Marathon now attracts more than 20,000 runners from around the world.

Below: (left) The Dragon Boat Race on the Charles River is always a highly anticipated part of the Dragon Boat Festival, which commemorates the life and death of China's patriot/poet Qu Yuan, who lived from 340−278 в.с. (right) New England Patriots quarterback Tom Brady points during a game in Foxboro against the Washington Redskins. The Patriots won 41−0.

© DAVID BERGMAN/CORBIS

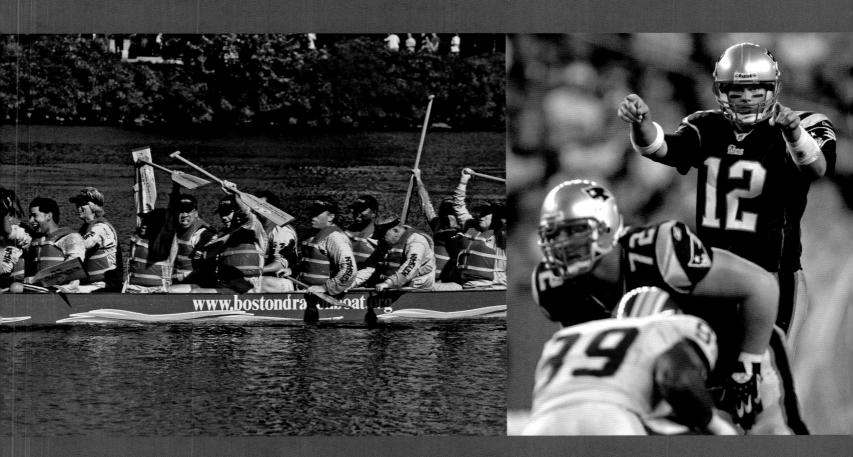

Facing page: King's Chapel was built on a corner of the colony's burying ground after King James II ordered that the Church of England have a presence here.

Below: (left) Leif Eriksson, by Anne Whitney, was installed on Commonwealth Avenue in Back Bay around 1887. (right) King's Chapel Burying Ground is the oldest cemetery in Boston, the final resting place for many colonists, including John Winthrop, the colony's governor; Hezekiah Usher, the colony's first printer; and Mary Chilton, the first woman off the Mayflower.

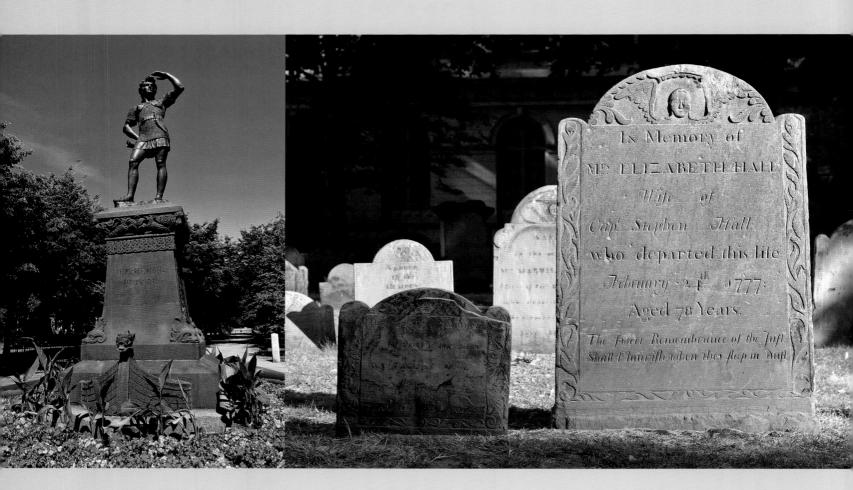

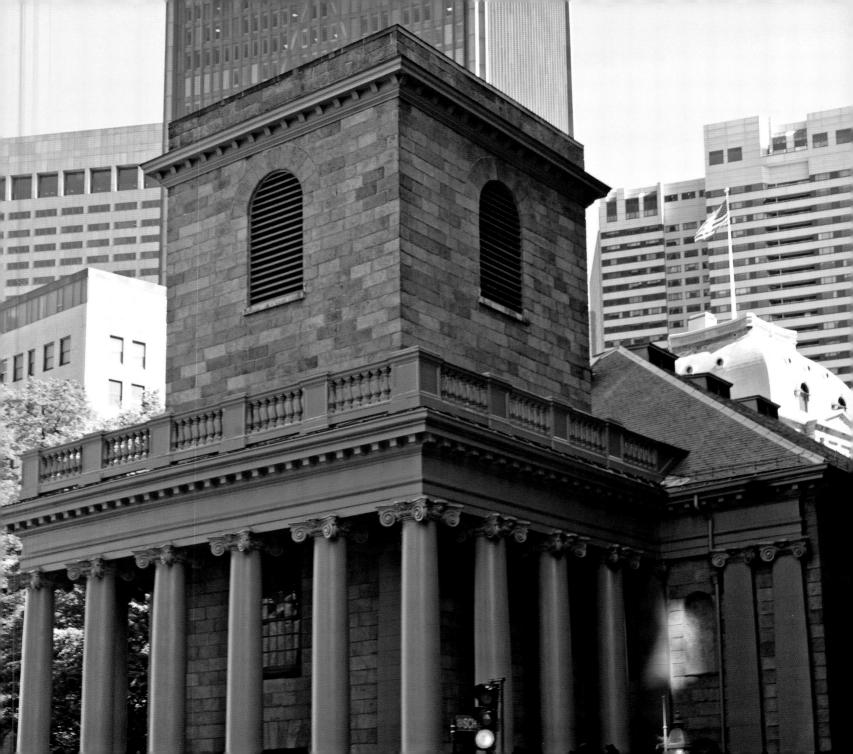

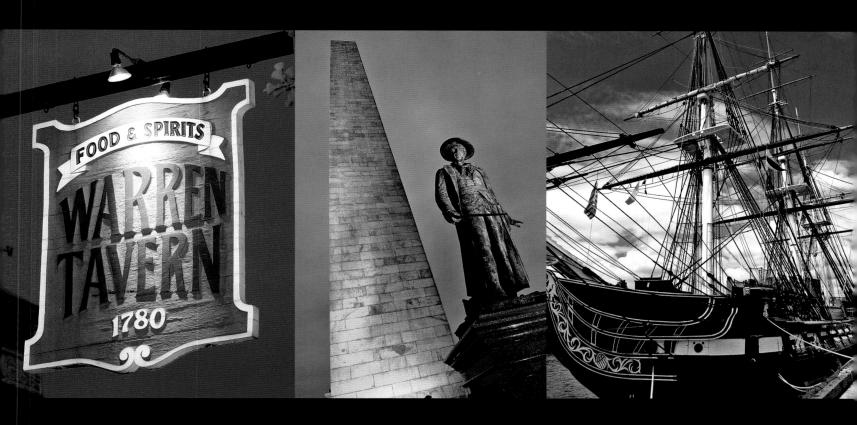

Above: (left) Warren Tavern has been serving libations and sustenance since 1780. (middle) A granite obelisk honors the colonists who died on June 17, 1775 in the Battle of Bunker Hill, the first major battle of the American Revolution. The rebels lost the battle, but nearly half the British troops were killed or wounded, which influenced the redcoats' later decision to abandon Boston. (right) The U.S.S. Constitution, launched in 1797, was made famous during the War of 1812, when it earned the nickname "Old Ironsides" for its thick-hulled ability to ward off British cannonballs.

Facing page: Immaculately maintained homes line a street in Charlestown, another of Boston's distinct neighborhoods.

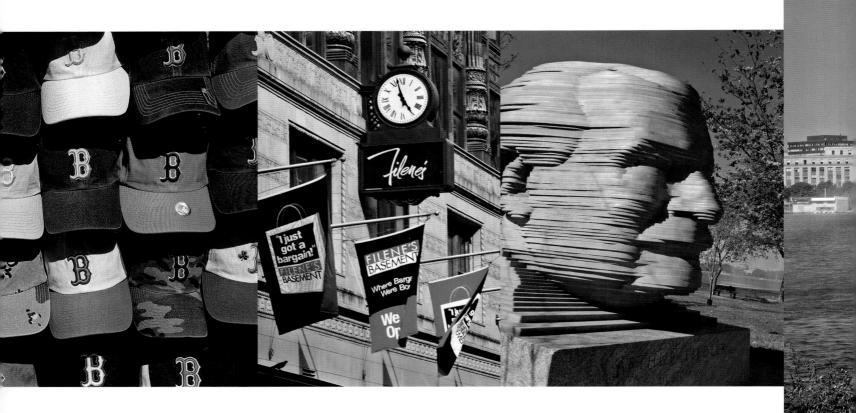

Above: (*Ieft*) Multicolored hats show off a future owner's pride in the Boston Red Sox. (*middle*) The clock at Filene's keeps City Crossing shoppers on time. (*right*) A unique bust of Arthur M. Schlesinger, Jr. at the Hatch Shell commemorates this Boston resident's contributions to chronicling the Kennedy era in American history.

Right: Any mode of travel may get you to the end of the rainbow on the Charles River.

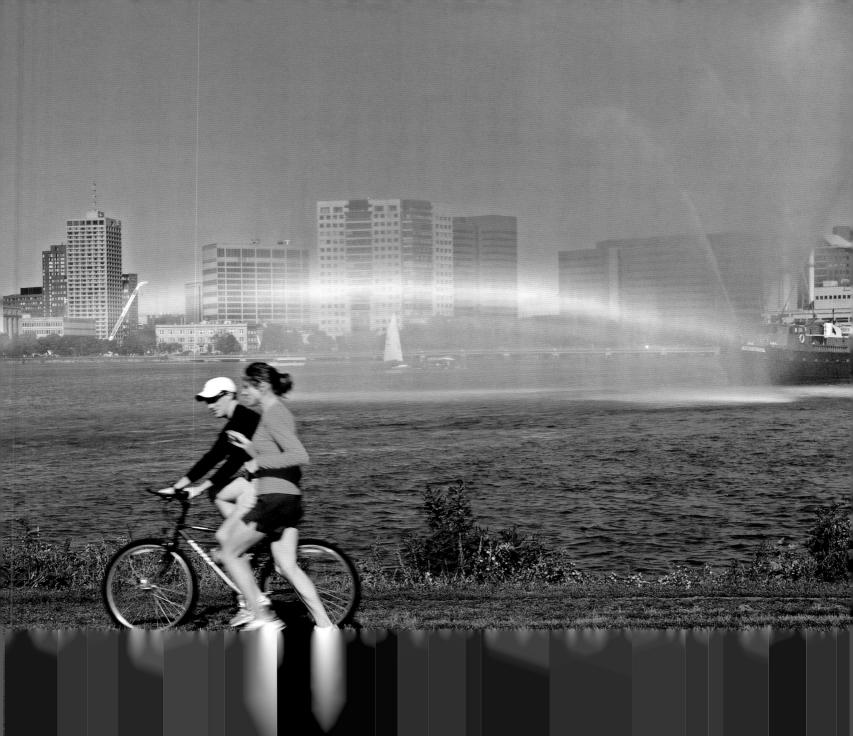

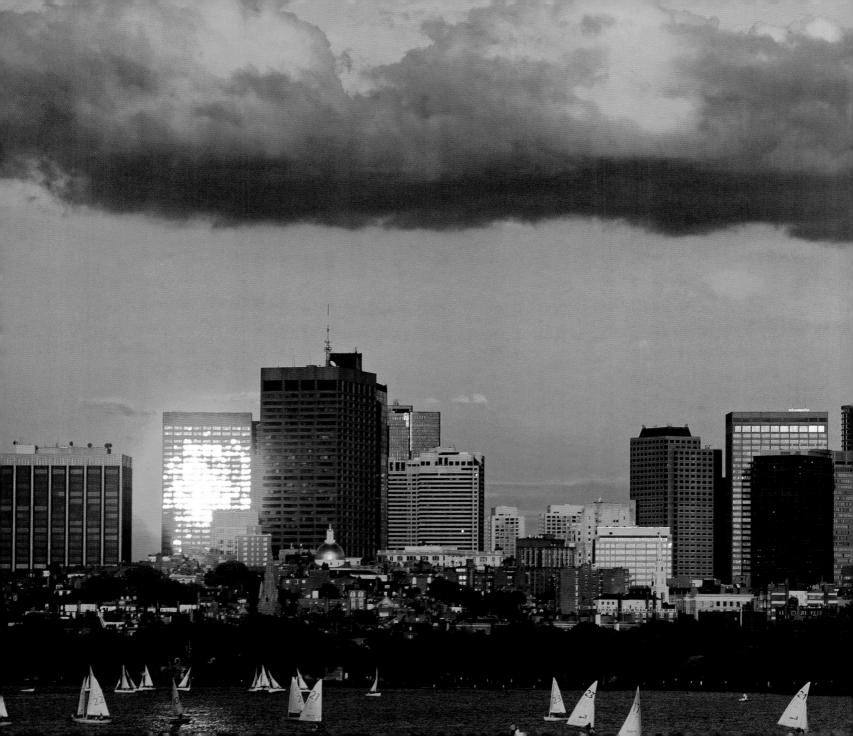

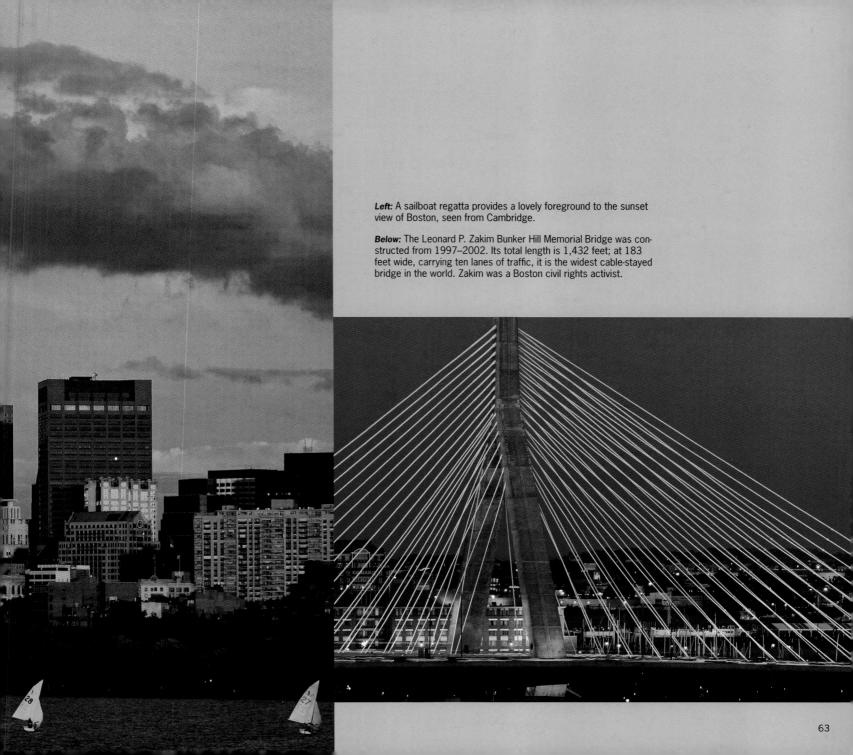

Right: Dipping toes in Walden Pond, in Concord. The pond was made famous in writer Henry David Thoreau's *Walden*, which is thought to have launched the movement toward greater environmental awareness. Walden Pond has been designated a National Historic Landmark.

Below: (left) The National Heritage Museum in Lexington was founded and is supported by 32° Scottish Rite Freemasons. The eye symbol is used by Masons. The museum chronicles the rich tapestry of life in America. (right) A statue at Minute Man National Historic Park gazes at a reenactment of the opening battle of the American Revolution.

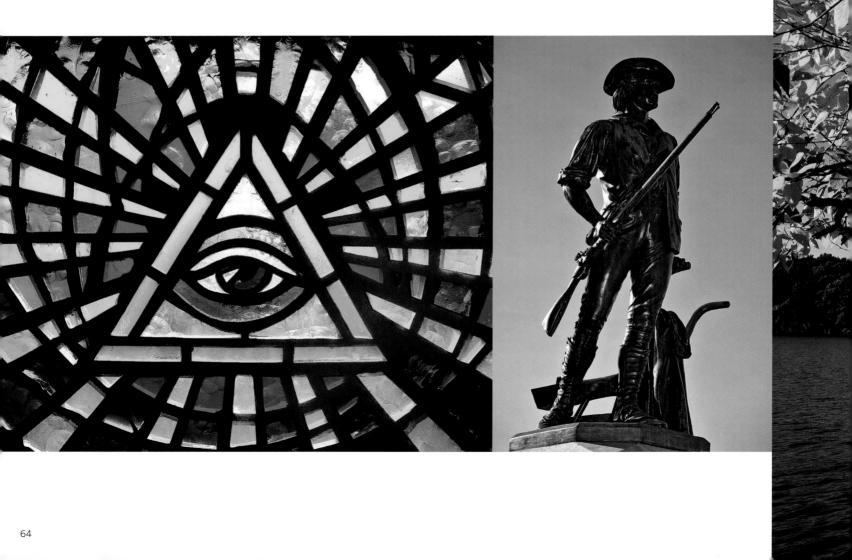

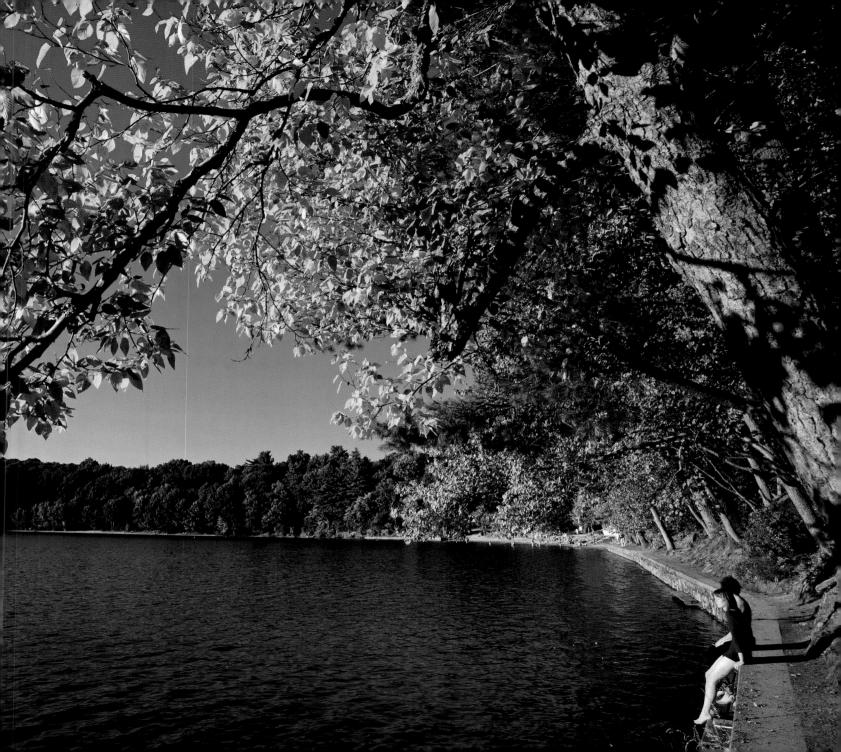

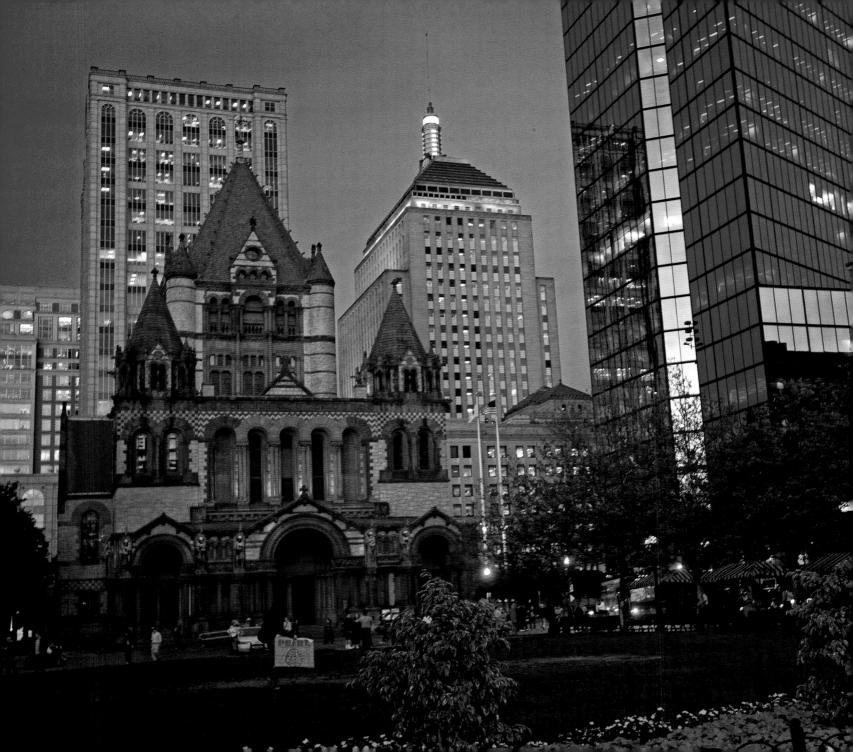

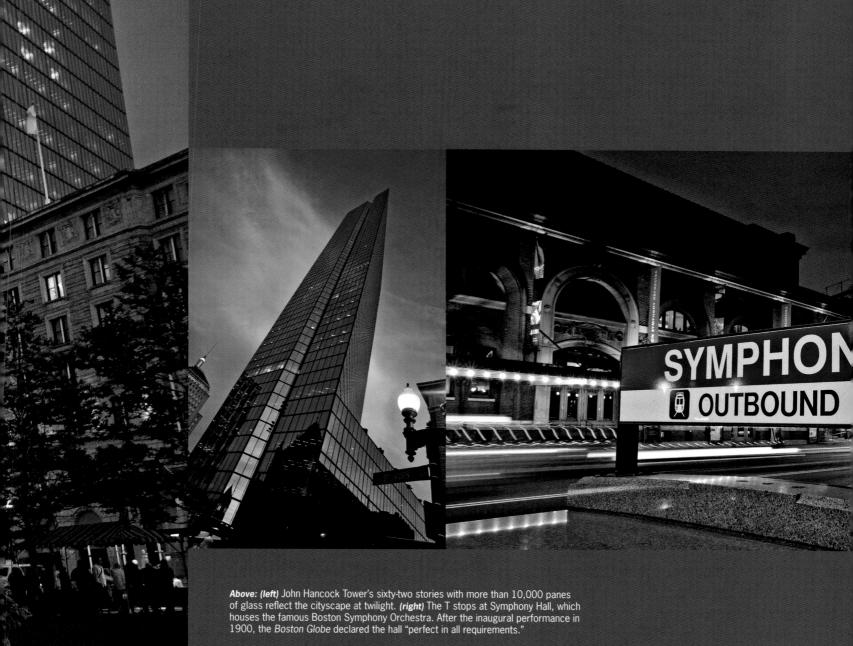

Left: Trinity Church faces Copley Square. More than 100,000 visitors each year come to see this masterpiece designed by American architect Henry Hobson Richardson.

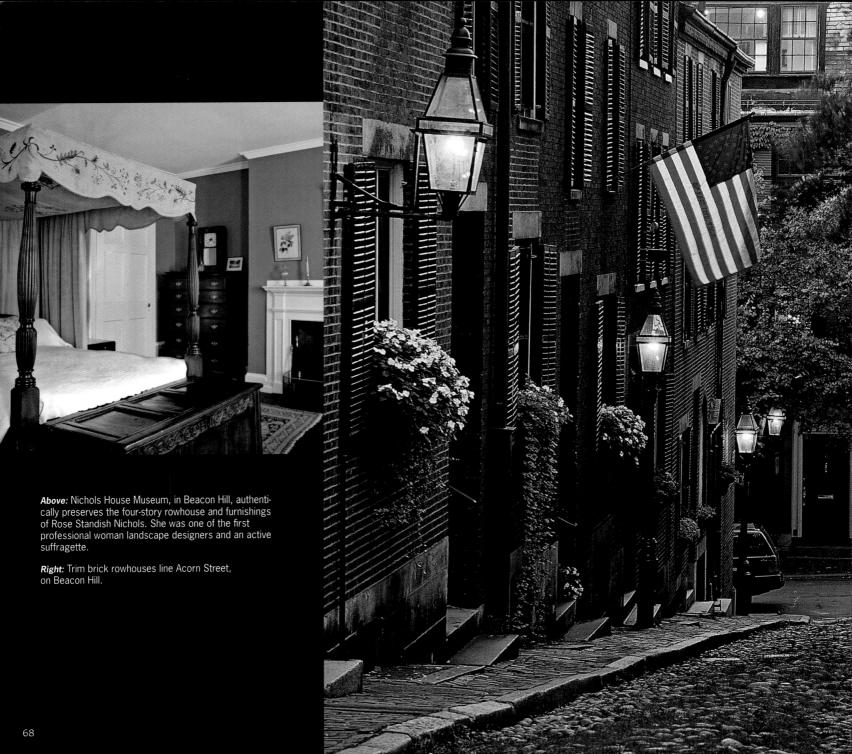

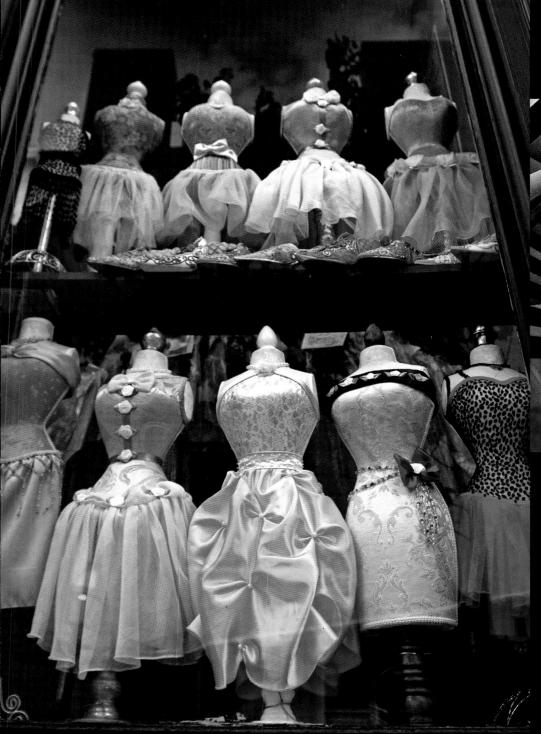

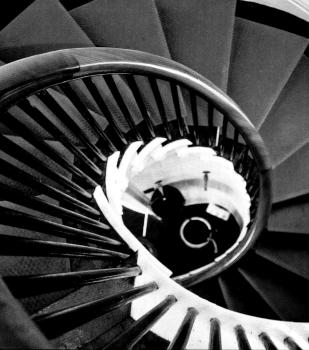

Above: Nichols House Museum preserves this exquisite spiral staircase designed by prominent architect Charles Bulfinch.

Left: Grab your corsets, ladies. This dress shop in Beacon Hill exhibits irresistible dresses from another era.

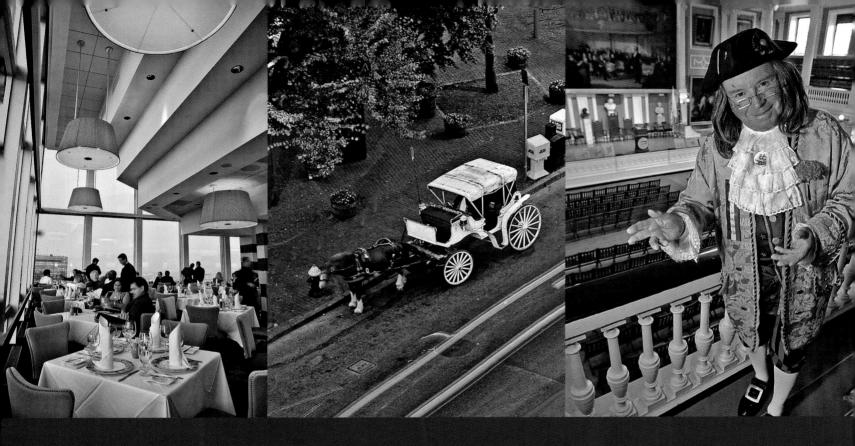

Above: (left) Top of the Hub Restaurant is perched on the fifty-second floor of the Prudential Center's tower. (middle) Horse and carriage await riders outside the Faneuil Hall Market Place, which has housed market stalls since 1742. (right) Inside Faneuil Hall, an actor playing Ben Franklin greets tourists. The hall has heard great orators, including Samuel Adams, Frederick Douglass, William Lloyd Garrison, and Lucy Stone.

Facing page: Top of the Hub Restaurant provides a fabrillous view of the surroundings

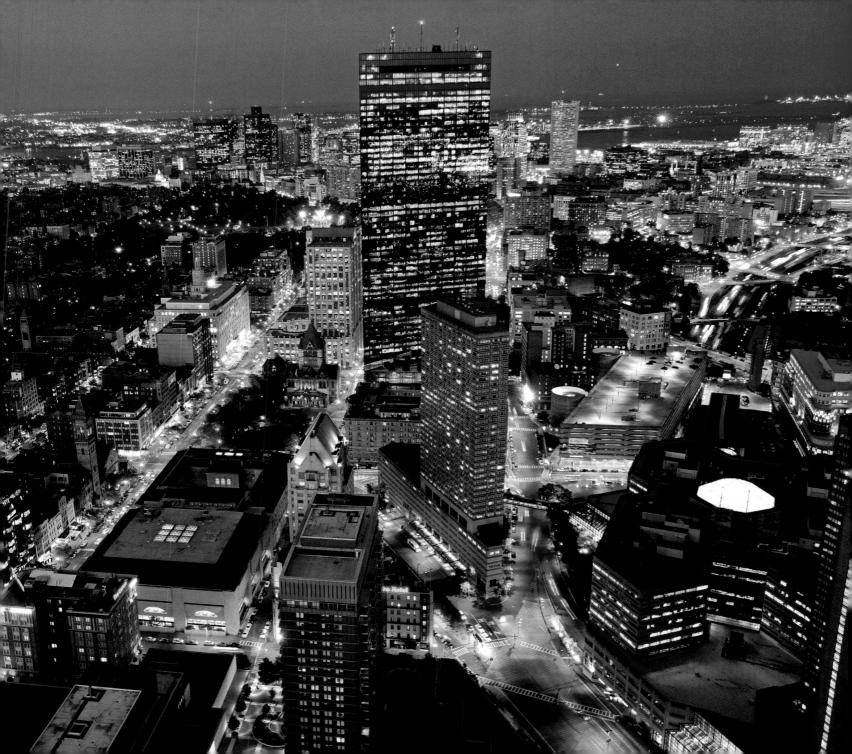

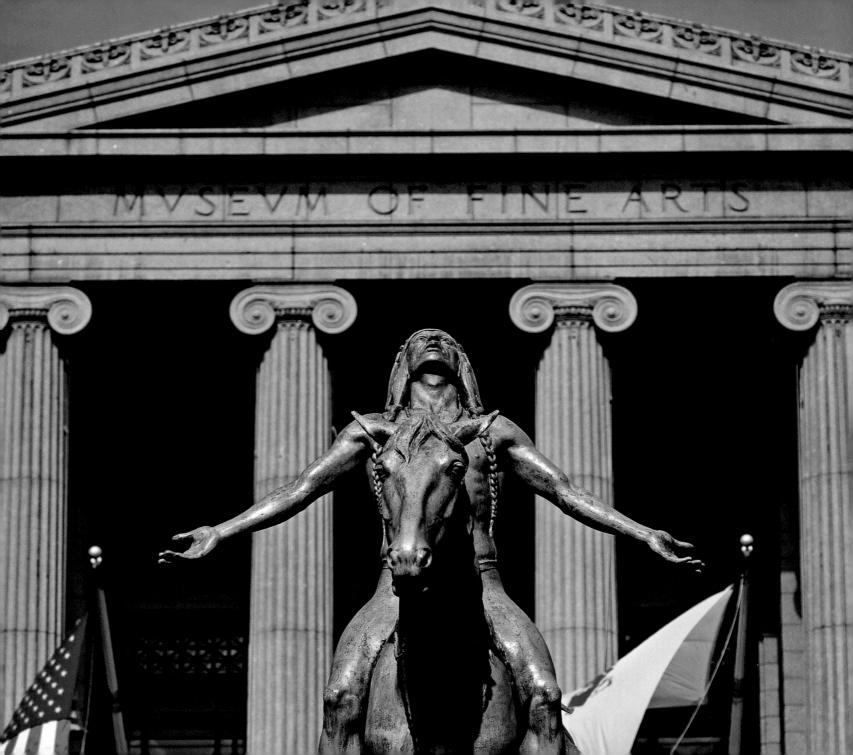

Below, left and center: The newly renovated and expanded Museum of Fine Arts encourages interactions between art and people. Opened in 1876, the original building housed 5,600 works of art in its 66,591 square feet, boasting galleries with barrel-vault ceilings. The expansion begun in 2007 adds 133,500 square feet. (facing page) Appeal to the Great Spirit by Cyrus E. Dallin greets visitors arriving at the Huntington entrance. (below, right) people outside the West Wing see Walking Man by Jonathan Borofsky.

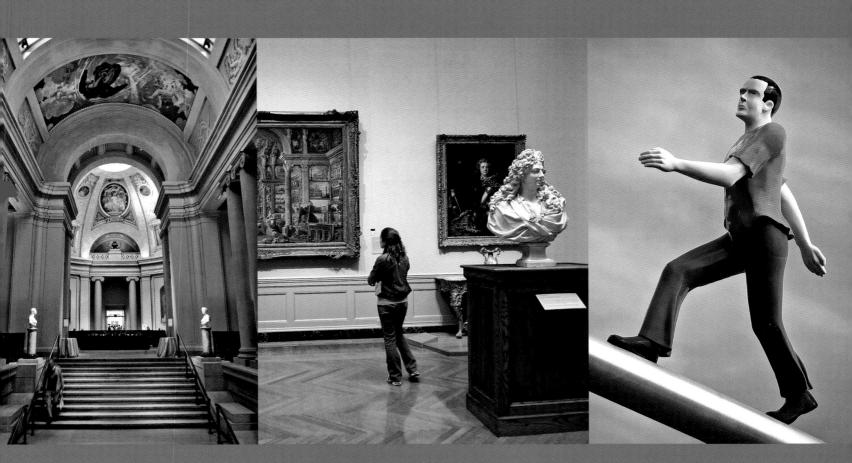

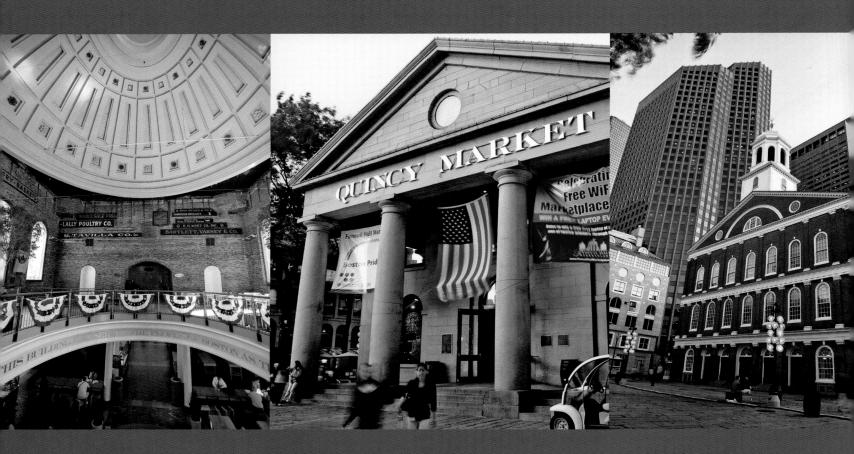

These pages: Faneuil Hall, also known as Quincy Market, has maintained a vibrant commerce near the old town dock for nearly three centuries. Four of the five Massachusetts signers of the Declaration of Independence are represented in the artwork displayed here—the missing delegate is Elbridge Gerry.

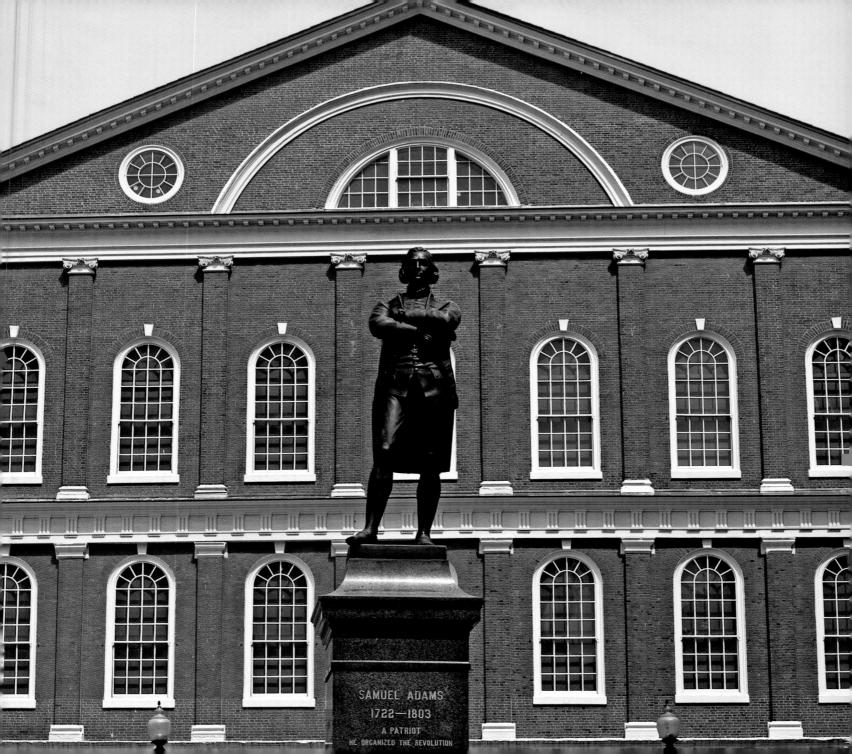

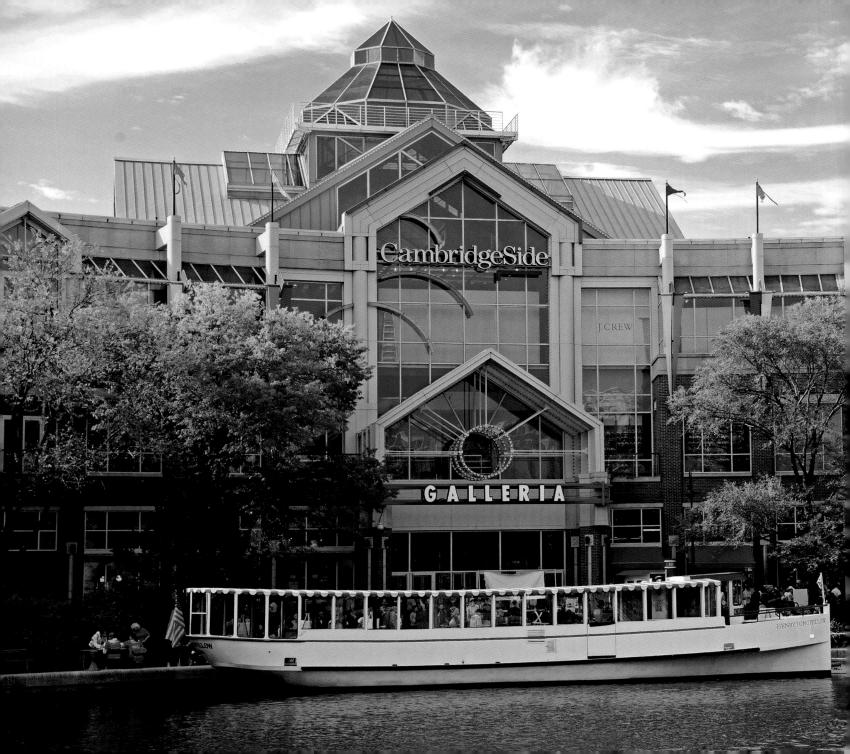

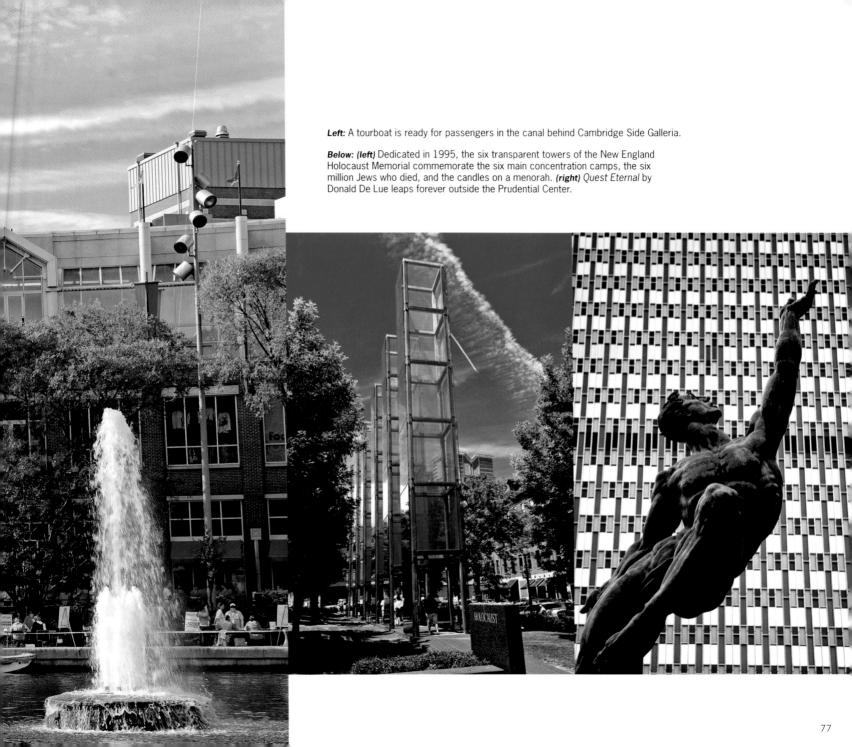

Right: Christian Science Plaza houses several buildings in the Back Bay. The original Romanesque church was built in 1894; the domed addition came in 1906. Inside, the organ, built by the Aeolian-Skinner Company of Boston, is one of the largest in the world with 13,290 pipes.

Below, left to right: The Museum of Science attracts more than 1.6 million people each year to the hundreds of interactive exhibits, from a theater of electricity to a bird's world to a planetarium. The brainchild of the Boston Society of Natural History (founded in 1830), the 1864 museum was the first in the nation to embrace all the sciences under one roof.

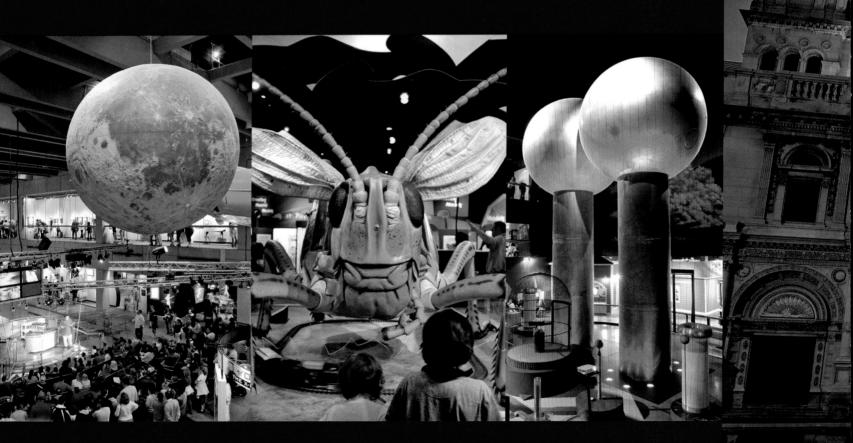

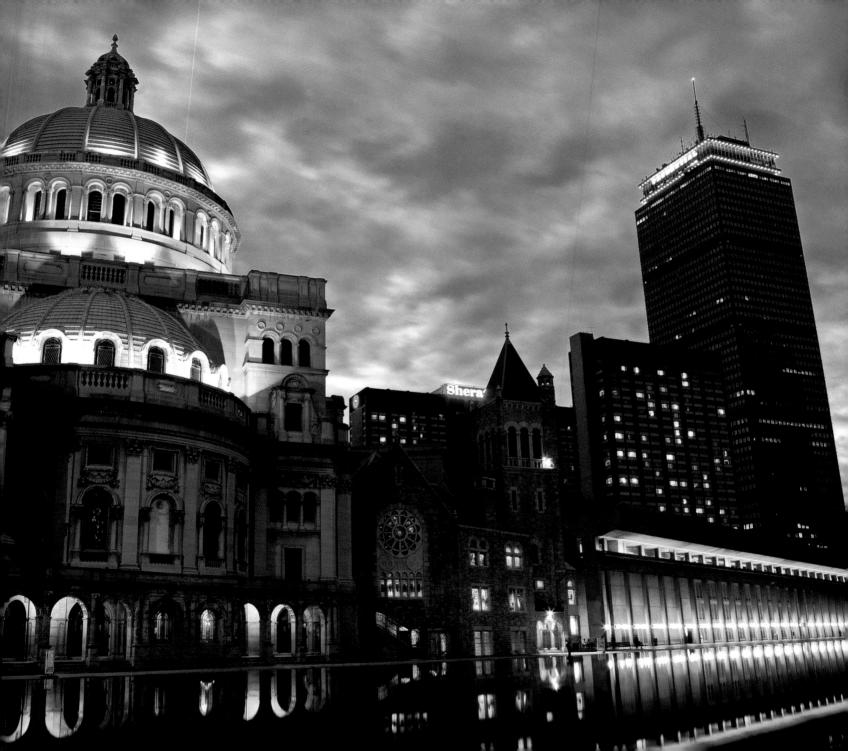

Richard Nowitz's (above, middle) photographs regularly appear in the world's leading travel guides and magazines. He has more than twenty-five large-format photo books to his credit. Nowitz has been a contract photographer with National Geographic World, Traveler and Book Division. His photograph of camels at Giza was selected as the logo for the National Geographic TV News Channel. His photos are syndicated worldwide through the Corbis and National Geographic Image Collection, and his own award-winning web site is www. nowitz.com.

Nowitz's children, Abraham (above, right) and Daniella (above, left), have traveled extensively with Richard since childhood. They learned photography from him and contributed photos to this book. As a teenager Abraham added a passion for writing to that powerful duo of travel and photography. Daniella worked for the National Geographic Channel as a video editor. She has contributed photos to many of his assignments around the world.

Right: A statue of Benjamin Franklin stands watch outside the old City Hall, along the Freedom Trail.

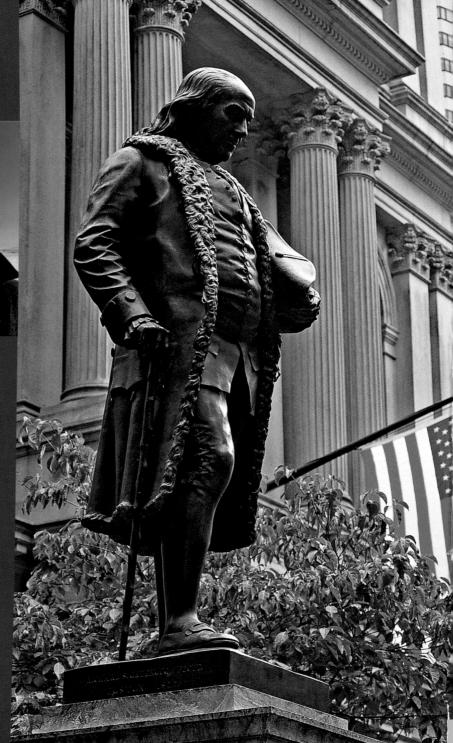